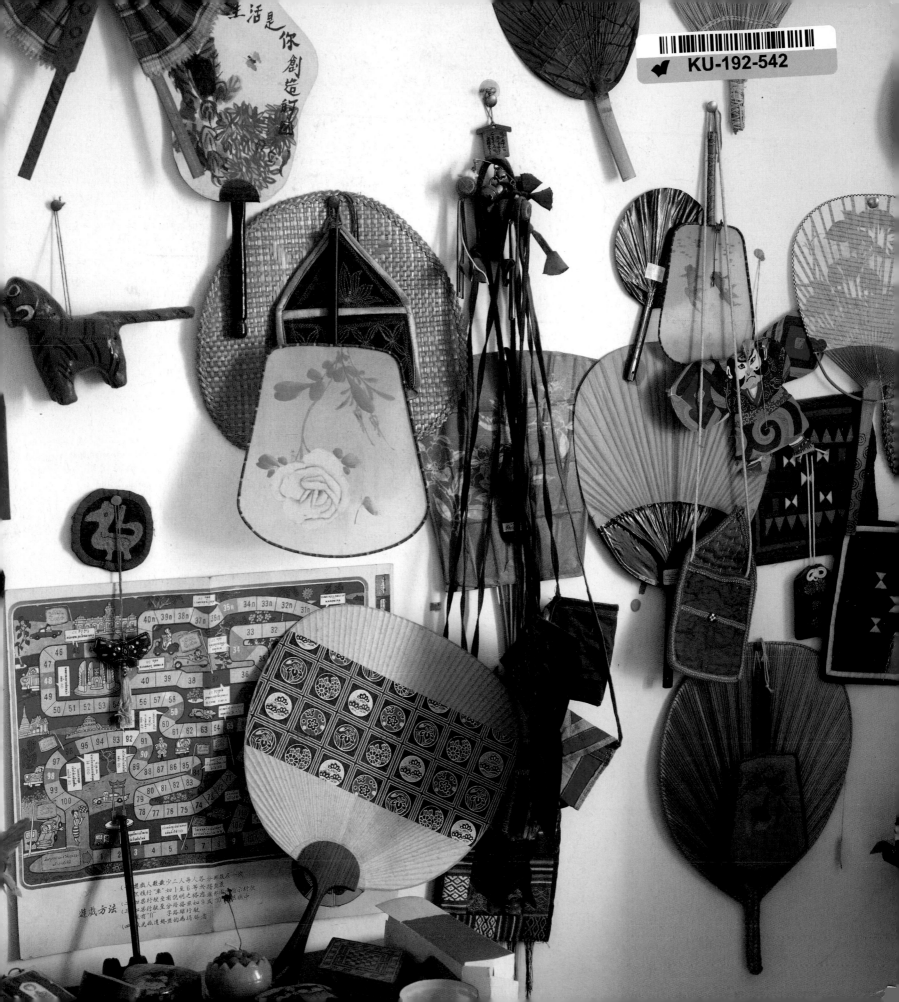

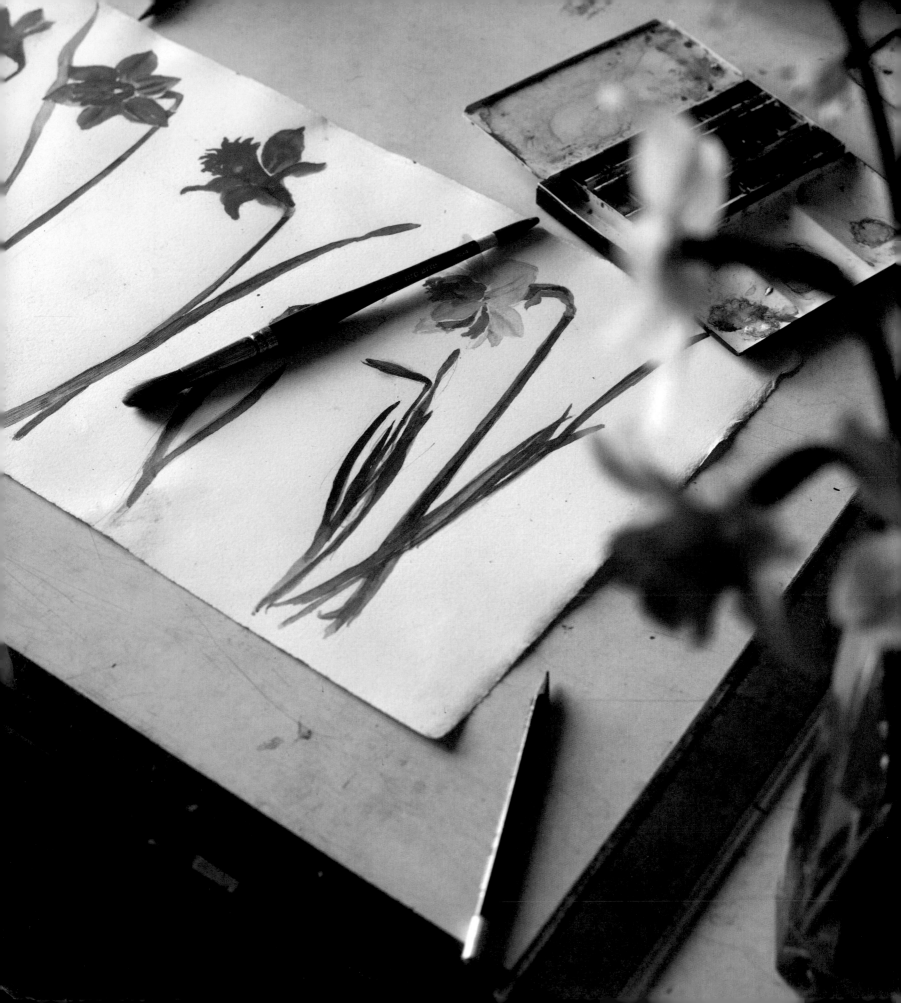

PHILIP LONG

with an introduction by John Leighton

Elizabeth Blackadder

NATIONAL GALLERIES
OF SCOTLAND · 2011

Published by the Trustees of the National Galleries of Scotland to
accompany the exhibition, *Elizabeth Blackadder*, held at the Scottish
National Gallery, Edinburgh, from 2 July 2011 to 2 January 2012.

ISBN 978 1 906270 39 1

Photography by John McKenzie; Antonia Reeve [7, 10, 25];
Simon Hollington [40]; Todd-White Art Photography [52];
Courtesy Perth Museum and Art Gallery, Perth and Kinross Council,
Scotland [71]; Courtesy Glasgow Print Studio [68, 90, 92]

Designed and typeset in Warnock by Dalrymple
Printed on Perigord 150gsm by Conti Tipocolor, Italy

Front cover: detail from *Orchids and Pears*, 1985 [55]
Scottish National Gallery of Modern Art, Edinburgh
Back cover: *Oriental Poppy in a Blue and White
Portuguese Jug no.2*, 2006, Private collection

All dimensions are given in centimetres, height proceeding width

The proceeds from the sale of this book go towards supporting the
National Galleries of Scotland. For a complete list of current publications,
please write to: NGS Publishing, Scottish National Gallery of Modern Art,
75 Belford Road, Edinburgh EH4 3DR or visit our website:
www.nationalgalleries.org

National Galleries of Scotland is a charity
registered in Scotland (no.SC003728)

NATIONAL
GALLERIES
SCOTLAND

BAILLIE GIFFORD

INVESTMENT MANAGERS

Baillie Gifford is delighted to be sponsoring the major summer exhibition at the Scottish National Gallery from July 2011. The Elizabeth Blackadder retrospective in honour of her eightieth birthday promises to be a wonderful exhibition in a magnificent setting.

We have worked on previous events with the National Galleries of Scotland and have always been impressed with their professionalism and creativity. We are proud to be associated with this outstanding event which enables a great Scottish painter to display some of her artistic repertoire.

Based in Edinburgh for more than 100 years and employing more than 650 people here, we have pleasure supporting artistic excellence which enhances the quality of our lives in this great city.

On behalf of the partners and staff at Baillie Gifford, we all hope you enjoy this exhibition.

BAILLIE GIFFORD & CO

DIRECTORS' FOREWORD

Among the first works to be purchased in 1960 for the newly established Scottish National Gallery of Modern Art were two fine lithographs, *Tuscan Landscape* and *Dark Hill, Fifeshire,* by the young Elizabeth Blackadder. Then a recent graduate beginning to make her mark upon Edinburgh's art scene, her outstanding ability and many decades of subsequent commitment both as teacher and practitioner means that she is now rightly recognised as one of our most distinguished and serious contributors to Scotland's culture. This book describes that achievement and accompanies a definitive retrospective of Blackadder's work, organised to mark the artist's eightieth birthday. The National Galleries of Scotland has been honoured to undertake this and we would like to express our deepest gratitude to Dame Elizabeth for her generosity of time, when no doubt she would have been hard at work in the studio.

Elizabeth Blackadder's work has been collected widely since her first solo exhibition, held in Edinburgh in 1959. We have been most fortunate to have had such support for the exhibition from the many institutions and private collectors who have willingly agreed to loan works. To them we express our very great thanks and to the numerous others who have given additional help and advice. We would we like to record our particular thanks to Gillian Raffles (formerly of the Mercury Gallery); Guy Peploe (of The Scottish Gallery); John Mackechnie and Kerry Paterson (of Glasgow Print Studio); and Joshua Darby (of Browse & Darby), all of whom have worked with Dame Elizabeth from their respective galleries over many years. Additional thanks are due to Annabel Macmillan who undertook indispensable research into holdings of the artist's work and her life's chronology which appears in this book. Within the National Galleries of Scotland, the exhibition has been selected and curated by Philip Long, Senior Curator. This will be the last exhibition that Philip is involved in at the National Galleries of Scotland before he moves on to new challenges as director of the V&A in Dundee. We are extremely grateful to Philip not just for his inspired guidance of this project but also for his long and highly distinguished track record as a curator at the Scottish National Gallery of Modern Art. Other colleagues have contributed with the utmost professionalism and we would like to thank in particular Rosalyn Clancey, Graeme Gollan, Kristina Johansen, Sam Lagneau, Lorraine Maule, Helen Monaghan, Tessa Quinn, William Snow, Gregory Stedman and Christine Thompson.

Finally, we are indebted to our supporters Baillie Gifford. Their enthusiasm for the exhibition has been especially welcome, and so to them our sincerest thanks.

JOHN LEIGHTON
Director-General of the National Galleries of Scotland

SIMON GROOM
Director of Modern and Contemporary Art,
National Galleries of Scotland

Elizabeth Blackadder

a celebration

JOHN LEIGHTON

As she approaches her eightieth birthday, there are no signs that Elizabeth Blackadder's passion for making art is in any way diminishing. On a visit to her studio in an imposing villa in suburban Edinburgh, I ask if she is setting new artistic goals. The answer comes with a dismissive shrug of the shoulders; 'I just keep on painting'. There are several canvases underway in the studio; watercolour studies lie half-completed on tables or on the floor; a vast collection of objects and souvenirs clutters every surface, evoking not just a lifetime of memories but suggesting a latent creative energy, a vast resource of raw material that will find its way in some form or another into future works. How does she feel about her forthcoming exhibition at the National Galleries of Scotland? Another modest shrug: 'I just keep painting.'

This exhibition has been designed to survey Blackadder's work across almost six decades. In simple career terms, her success can be mapped out easily with impressive lists of exhibitions, steady sales, and official honours. She has produced a large body of work, diverse in approach but consistent in quality, which is represented in museums and private collections across this country and beyond. Yet, in spite of all these accolades, there remains a lingering sense that Blackadder's art has not received the attention it deserves, both in national and international terms. Perhaps this is because the power of her art is sometimes masked by the charm of her subject

matter or the deceptive ease of her technique. Perhaps our taste has become more attuned to the loud and the brash in art at the expense of quieter mastery and refinement. Certainly, the painter's natural reticence and modesty seem at odds with the extravert outpourings of many contemporary artists. Whatever the reasons, we still seem some distance from establishing a definitive view of Blackadder's achievement. This book, therefore, is both a celebration and an invitation to look again at the work of one of our greatest living painters.

This discreet and least public of artists is probably more comfortable when talking about method rather than meaning. She has an amazing command of her artistic craft and will talk happily about techniques and materials; about the weight and texture of paper or the qualities of paints, inks, and other aspects of the artist's business. From its earliest stages, her work has been underpinned by superb draughtsmanship and a breathtaking ability to find equivalents in paint for her observations and memories. She recalls the huge emphasis on drawing in her academic training at Edinburgh College of Art and this has remained an anchor point for her work ever since. From the raw and powerful drawings made on early trips to Italy through to her most recent studies in pencil and watercolour of flowers and plants, part of the pleasure of her work lies in admiring the brilliance of her craftsmanship. When it comes to discussing the meaning and aims of her work,

however, Blackadder prefers to leave the response open to the individual viewer.

All the time I am trying ... to create a mood, which I suppose comes from my own recollections in time and place of the various shapes and objects, and the relationship that I have with them. Someone else looking at the finished painting may well read or relate to its mood in a different way, but I don't think that really matters.[1]

Blackadder's approach has always been highly intuitive. Her paintings are only loosely planned and are allowed 'to grow by themselves'.[2] This emphasis on her art as an unfolding process, with its own internal momentum, has at times taken Blackadder close to abstraction and at other moments led her to create very literal paintings and studies. When it suits, she has adopted the freedom hard won by artists of the late nineteenth and early twentieth centuries to manipulate space, to exaggerate forms and to use the canvas or sheet of paper as an imaginative field with its own set of rules. In the relationships of colours and forms, and in the dialogue between space, depth and the interplay of shapes and objects, she teases out associations and moods, creating her visual equivalent of poetry; rooted in observation, with familiar subjects, yet treated with great imagination and invention.

The artistic journey that is mapped out here is not marked by dramatic twists and turns but follows a path

of gradual transitions and experience. Nevertheless, there are important shifts and moments of breakthrough. There is a turning point at the end of the 1950s, for example, when a sombre, close-toned student style gives way to a more open, expressive approach. This is followed by a period of increasing experimentation and liberation in the 1960s and early 1970s as her work becomes less descriptive and less bound by conventional rules of perspective. In her still lifes of the mid-1960s, for example, the objects begin to float more freely against backgrounds that have become accumulated layers of paint rather than representations of tables or cloths. While she holds on to recognisable forms, often depicting objects in loving detail, her visual excitement is conveyed in exuberant colour and expressive handling of paint, and in the elaborate embroidery of shape and pattern across the surface.

Another important phase begins around 1975, when Blackadder moved to her present home. Her art seems to become more calm and reflective. Still lifes and interiors begin to dominate her work, evoking a private, intimate world of revered objects, elegant cats and harmonious domesticity. A lifelong interest in botany comes to the fore in paintings of plants and flowers, culminating in extra-ordinary watercolours of the late 1980s and 1990s. Inspired by earlier botanical artists and by the example of William Gillies, Anne Redpath and John Maxwell, she 'began to look at the real thing with a fresh eye'.[3] These studies, which she has continued to make to the present day, count among her most distinctive achievements. Far from being a lapse into slavish naturalism, these astonishing works play on tensions between discipline and spontaneity, between artistic labour and freshness of vision. Making and meaning are inseparable in these intense works and, as Duncan Macmillan notes, 'it is the communion between that immediate, practical feeling expressed in the process and its extension into the subject that is the special alchemy of her art'.[4]

Blackadder's career has been focused on Scotland. She has found sustenance and support for her work in her contact with several generations of Scottish artists, in her career as a tutor at Edinburgh College of Art and, of

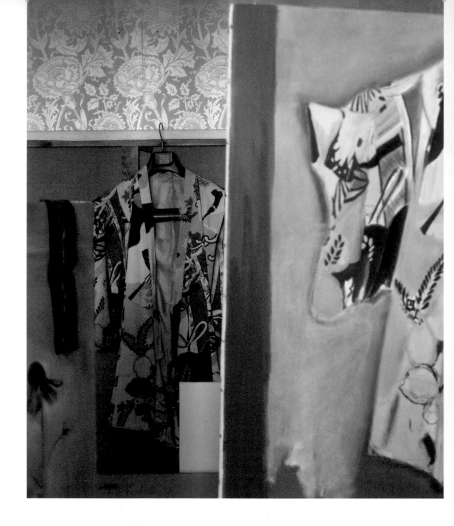

course, her marriage to another great Scottish artist John Houston. Her ongoing admiration for the art of her mentor Gillies is still apparent, perhaps also for Redpath, but her Scottish roots have always been nourished by exposure to a diverse range of artistic styles and approaches, from Bonnard and Matisse through to Pop Art and American Abstract Expressionism. She has always had a broad interest in art history. She followed the joint Fine Art course in Edinburgh which combines practical study at the art college with art history at the university, and it was probably under the inspired tutelage of David Talbot Rice that her curiosity for non-Western art began to emerge. Encouraged by a taste for travel, her interests have ranged across Byzantine art, Indian miniatures and the art of the Far East. Perhaps her most enduring enthusiasm has been for Japanese art and culture. This is reflected in her extraordinary Japanese-inspired watercolours and then oil paintings of the 1980s onwards. Here, the objects seem contemplated rather than observed and as viewers we are invited to participate in an intimate, meditative experience. The art of Japan heightened Blackadder's reverence for materials and for the spontaneous, fluid touch of the artist's hand on beautiful surfaces. Perhaps it also heightened her sense of the picture as a crafted object, embellished by additional materials such as gold leaf or collaged papers. Most importantly it allowed her to experiment with new formats, ranging objects across horizontal sheets of paper and canvases, creating a dream-like flow of memories and poetic associations.

Many claims could be made for Blackadder's art and her achievement. As this exhibition shows, she has helped to revitalise long-established traditions of landscape, still life and flower painting in Scotland. She has taken forward the painterly freedom of earlier generations and fused it with more modern concerns for the intrinsic power of colour and decoration. She could be described as one of our finest painters in watercolour or equally lauded for her work as a printmaker. At once profoundly Scottish and enticingly exotic, her art is both familiar and mysterious. Perhaps her greatest achievement is to have developed an art that is highly personal, private even, yet one which is still so very

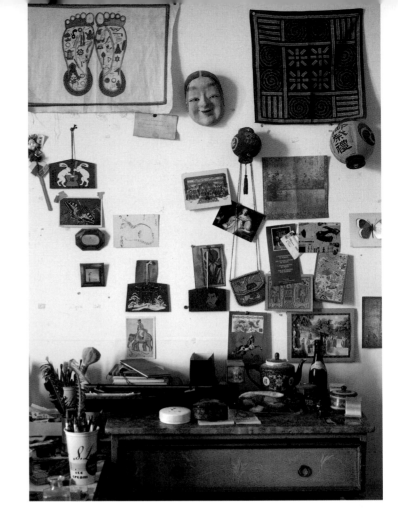

accessible and beautiful. The story is far from over. Today, in her studio, she continues to conjure up memories and sensations and convey them on canvas. A kimono, hanging from a wall, provides the basic motif for an interior scene. For another still life, her cool, analytical eye dwells on the mottled texture of a watermelon while, on the floor, other sheets are filled with studies of lobster shells. Elsewhere, objects of all kinds silently wait their turn. Apparently there remains much to be done and while we celebrate, the artist quietly keeps on painting.

1. Elizabeth Blackadder, *Elizabeth Blackadder: The Artist at Work in Her Studio*, London, 2002, p.16.

2. Elizabeth Blackadder, ibid, p.12.

3. Judith Bumpus, *Elizabeth Blackadder*, Oxford, 1988, p.58.

4. Duncan Macmillan, *Elizabeth Blackadder*, Aldershot, 1999, p.9.

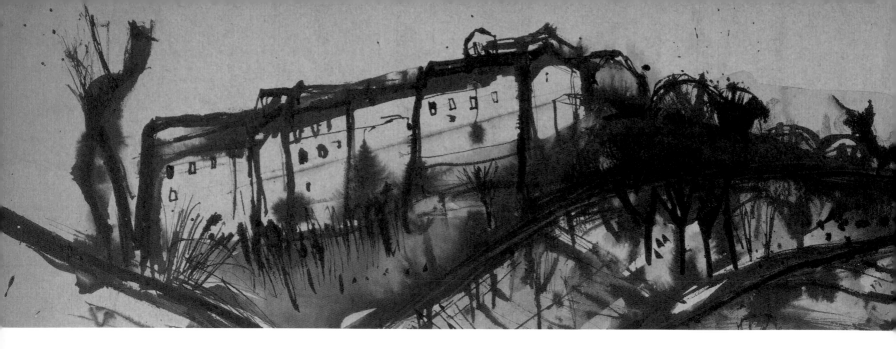

Elizabeth Blackadder
beginnings

Elizabeth Violet Blackadder was born on 24 September 1931 in Falkirk, mid-way between Glasgow and Edinburgh. Falkirk has a proud industrial heritage and the Blackadder family contributed significantly to this. Elizabeth's great-grandfather, Thomas Blackadder, established his own engineering firm there in 1851, and this continued as a family enterprise into the twentieth century as the Blackadder Brothers' Garrison Foundry and Engine Works. Elizabeth's grandfather and father both worked there. It was in the house built by her grandfather, at 6 Weir Street in Falkirk, that she was born, the second child of Thomas and Violet Isabella Blackadder, and where she spent her earliest years.

Young Elizabeth's grandfather, also Thomas, named the family home Glenmorag after the ship on which he had served his marine-engineering apprenticeship. He was particularly enterprising, and among the engineering drawings, set-squares and mechanical models that filled the house were objects collected from his business travels around the world. Blackadder still has some of the gifts she received from her grandfather – jewellery, tortoiseshell boxes, and a model Portuguese fishing boat – brought back from visits to the Continent, the Middle East and India. Elizabeth attended school in Falkirk at first, but following the outbreak of the Second World War she was sent to stay with her maternal grandmother at Kilmun on the Holy Loch in Argyll. Primary school in nearby Strone was followed by a brief period at Dunoon Grammar School.

Detail from *Impruneta*, 1956 [7]

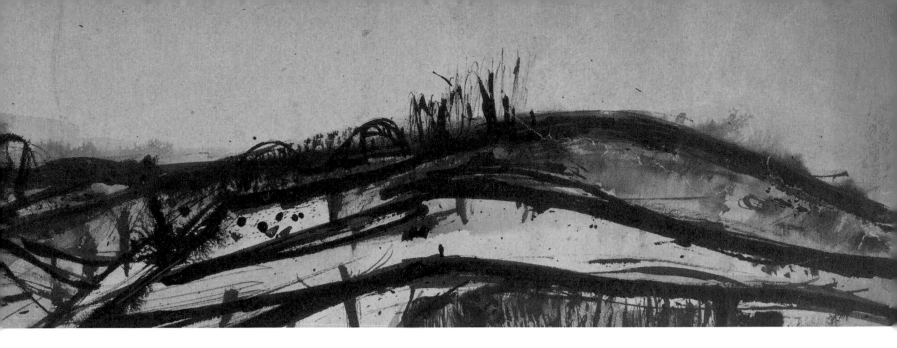

The Clydebank air raids could be heard ominously in the distance, and separation from her parents during these years of war took a tragic turn on the news of the death of her father. Life in Argyll was otherwise peaceful, characterised by reading with her aunts, practising the piano, and playing games along the shoreline.

On her return to Falkirk Elizabeth attended the High School there, and her mother worked as a domestic science teacher in order to support Elizabeth and her brother Tom, who went to study engineering at Glasgow University. At school, Elizabeth's favoured subjects were Science, History, English and Art, and she recollects the encouragement she received from the art master James Scott. Botany too had become an interest; while in Argyll a local minister had lent her books to read, and on his death she was allowed to choose from his library, selecting a botanical work, *Flowers of the Field*. In Falkirk, around the Union Canal, she collected and pressed flowers and at school decided to study Higher Botany, a new course at the time, enabling her to extend her interest in art into painting and drawing plants. Blackadder's industrious mother (whose educational ambitions had been thwarted by her own father) encouraged Elizabeth's university ambitions, but was less confident about a course in art, and for a while science was also an option. Blackadder was clearly an intelligent young woman and this was recognised when she was made head girl at Falkirk High School. Advice from a family friend, Professor T. Fergusson, Professor of Public Health at Glasgow University, brought to their attention a new degree in Fine Art offered by the University of Edinburgh in collaboration with Edinburgh College of Art, which combined academic study in art history with practical studio work in the college's nearby premises in Lauriston Place. An application was made, and a place gained.

Before setting off for Edinburgh, the family's professor friend provided an introduction to Tom Honeyman, the well-known director of Glasgow's Kelvingrove Art Gallery and Museum. Blackadder was offered a temporary position as a volunteer, which would give her useful experience in preparation for her degree. While there, during the summer of 1949, Blackadder gained experience in the gilding and framing department, and met one of the curators, Bill Macaulay, a connection she was eventually able to renew when she began to exhibit with The Scottish Gallery in Edinburgh, where Macaulay had become director.

The University of Edinburgh's Fine Art degree had been initiated shortly after the Second World War by Professor David Talbot Rice, whose academic brilliance in Byzantine studies and passion for contemporary art made him an inspirational teacher to his students and a respected figure within Edinburgh's artistic community. Edinburgh's masters degree in Fine Art is five years in duration, and continues to test those following the course, who can find themselves pulled between its academic demands and the

commitment required to practise as an artist. Blackadder recollects the excitement of her arrival in Edinburgh in 1949 where she had digs in a university hostel. Edinburgh College of Art was flourishing, reanimated by the return of students and teachers following the war. William Gillies was Head of the School of Drawing and Painting, with a staff that included Robin Philipson, William MacTaggart, Leonard Rosoman, Penelope Beaton and Robert Henderson Blyth. The latter two Blackadder recollects as being of particular influence. Beaton had studied at the college during the First World War (alongside Anne Redpath) and was appointed to the teaching staff in 1919, where she was responsible for first-year courses and introducing the new students to the disciplined and methodical teaching of the art college. Henderson Blyth had been a student at Glasgow School of Art and then at Hospitalfield (a postgraduate centre near Arbroath for the Scottish art colleges) under the tutelage of James Cowie, whose brilliant draughtsmanship made a deep impression on the younger artist, as it did on many others of that time.

Mid-twentieth-century Scottish art has been broadly characterised as having two tendencies: the more painterly, exemplified by the intuitive, observational approach of French-trained, Edinburgh-based figures such as Gillies; and the meticulous, harder-edged naturalism typified by the work of Cowie and his associates at Glasgow School of Art. To the extent that this distinction can be identified, it was certainly blurred by the Second World War, which decimated life in the art colleges through the removal of many tutors and students. Edinburgh College of Art had always required its students to follow the conventions of life drawing and anatomical study before progressing with more liberal methods. This did not change but the shake-up brought about by the Second World War resulted in the introduction of new blood and new methods, and the presence of Glasgow-trained Henderson Blyth, with his emphasis on compositional structure above painterly expression, inspired and gave a defining character to the work of a new generation of talented Edinburgh students graduating in the 1950s.

There is a muted sensibility in the modest self-portrait that remains from Blackadder's early years at college and in the portrait of her cousin Jean [3 & 4]. The artist recollects the pressures of completing the Fine Art degree, at times literally running between the college and the university's Fine Art Department, then at the junction of George IV Bridge and Forrest Road some half a mile away, in order to be on time for lectures. Classes at the college continued late into the evening, until 9pm, leaving little time for socialising. Despite this rigour Blackadder maintained both her practical and academic studies and made interesting connections between the two. At the college in her second year she had studied still-life painting with William MacTaggart, and for her final year academic thesis chose to write on the work of his grandfather, William McTaggart, the great nineteenth-century landscape painter. This interest in her own recent cultural heritage was considered a somewhat unconventional choice, but did not mean she was not interested in the broader history of art. Blackadder found Talbot Rice's teaching of Byzantine culture particularly inspirational, and upon graduating in 1954 with a first-class degree and a Carnegie Travelling Scholarship, she chose, at Talbot Rice's recommendation, to visit Italy, Greece and Yugoslavia to seek out the architecture and art of the Byzantine period.

That trip was made in the company of John Houston, a fellow student who had recently graduated from the art college. Houston had begun his degree a year earlier than Blackadder, and they did not meet until his postgraduate year in 1952, at a college dance. They shared common interests and introduced each other to new ones: Elizabeth enjoyed John's passion for jazz and Westerns and she shared with him her interest in classical music. Their love of art was naturally a close bond; John's first present to Elizabeth was a book on Piero della Francesca. In 1953 Houston had travelled to Italy with friend and fellow student David Michie, where they had sought out the work of contemporary artists such as Giorgio Morandi and Mario Sironi. With the benefit of that experience, John and Elizabeth set out together in 1954 on her own travelling scholarship, visiting Venice and Brindisi in Italy and travelling, at times with difficulty, through Yugoslavia and onto Greece, as far south as Athens and east to Thessaloniki, where both made studies from the Byzantine monuments [5]. On their return to Edinburgh

later that year Blackadder was awarded additional scholarships providing for a year's study within the college and in support of further travel.

Thus in the summer of 1955 she and John set out once again for Italy, with Elizabeth basing herself in Florence from September, after John's return to Edinburgh to take up teaching duties. There she lived in a *pensione* and came to know her Italian hosts well, learning a little Italian and helping them with English translation for their guests. A confident portrait drawing of one of the family, Gina, was made [1], and a more sensitively handled portrait of John may also date from then [2], but the works which demonstrate for the first time Elizabeth's superb ability as a draughtsman was the series of landscapes and architectural studies that she produced; it was not practical for Blackadder to paint in oil during these scholarship travels, and so her art relied primarily on her already prodigious ability with brush, pen and ink. A hillside at Impruneta [7] is rendered in bold strokes that converge in a complex mass of marks at the point where our eye follows the road as it turns out of view around the hill. Irregularities in the passages of ink read not as coarse application but as the

fine detail of walls and bare hedging. Much of Blackadder's time in Italy was spent during the harshness of winter, and the appeal to the artist of the landscape seen under these conditions is evident in *Winter Landscape at Assisi* [6]. White and pale blue-grey gouache is applied over the severe mass of the Umbrian hills, their scale made clear by the diminutive and bare forms of the trees lining the curving valley road. The drawings that perhaps made the greatest impression when shown at Edinburgh College of Art on her return (and subsequently in a show of young contemporaries at the Gimpel Fils Gallery in London in 1956) were those of Siena, Florence and Pisa [9–12]. Blackadder's eye analyses at once the overall massing, volume and surface decoration of these structures, as well as their fine detail. While the view of the Duomo in Siena is from a conventional perspective (allowed by its open situation), that of Florence's cathedral, hemmed in on all sides, takes a more adventurous viewpoint, drawn from the high bell-tower. The artist has got precariously close-up, allowing her to fill the sheet with architectural detail which runs rhythmically across the full breadth of the page. These masterful drawings signal the culmination of her student career.

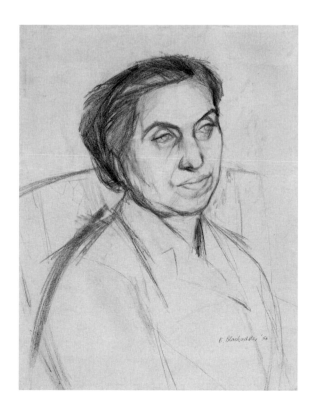

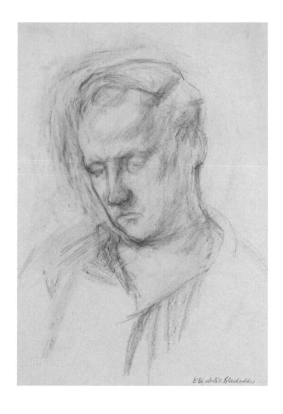

1 Head of Gina, 1956

Pencil on paper, 51 × 38
Private collection

2 Portrait of John Houston, *c.*1956

Pencil on paper, 52 × 37
Private collection

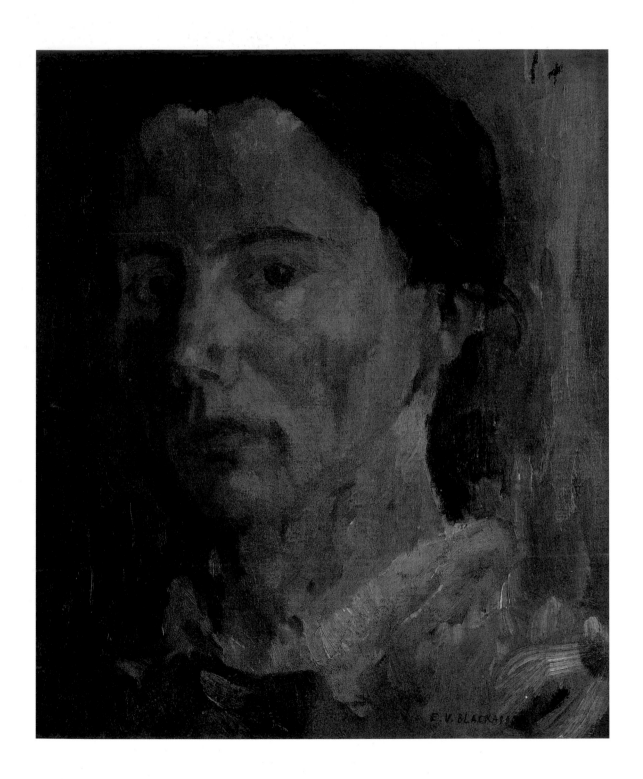

3 Self-portrait, 1951

Oil on canvas, 35.6 × 30.5

Private collection

4 Portrait of Jean, 1952

Oil on canvas, 91.5 × 61
Private collection

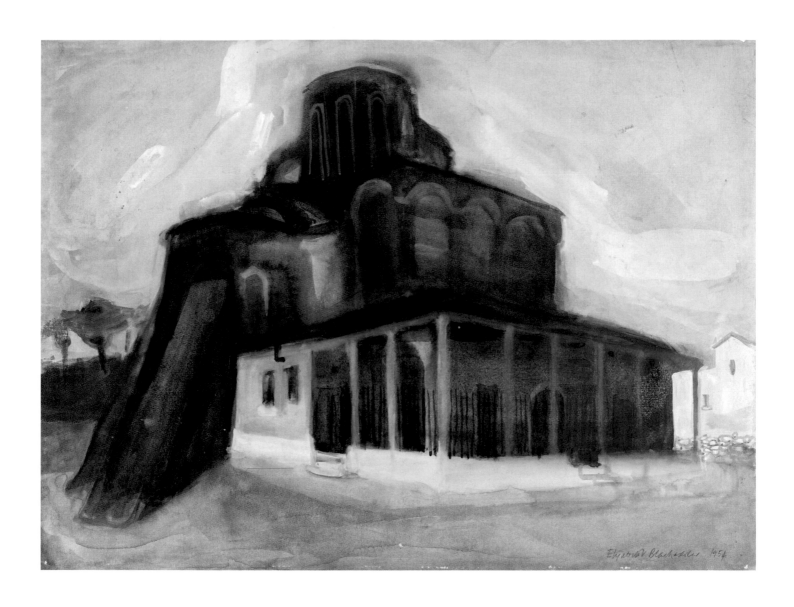

5 Church in Thessaloniki, 1954

Watercolour on paper, 38 × 51
Private collection

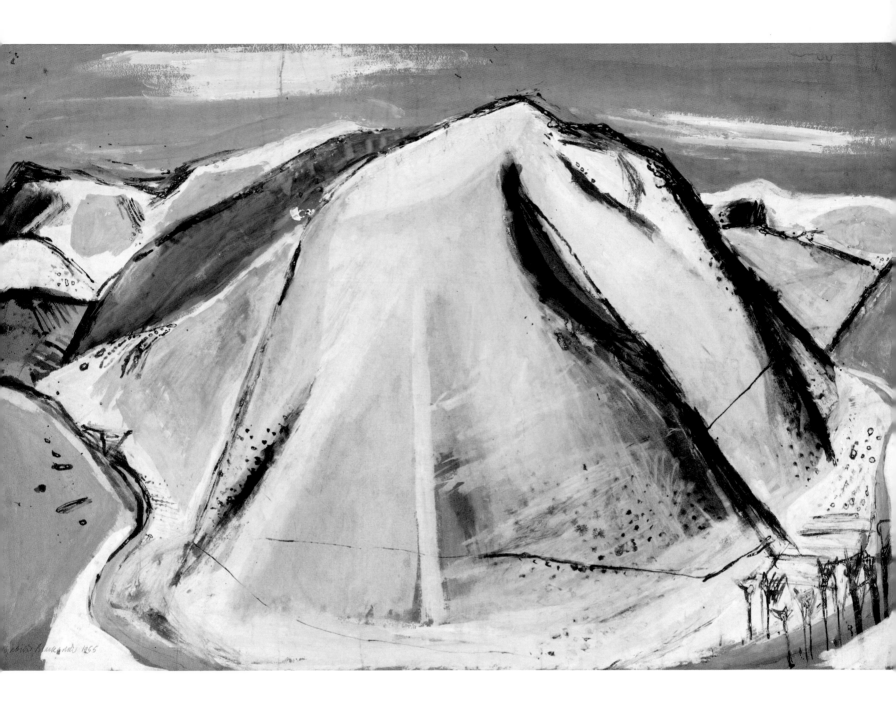

6 Winter Landscape at Assisi, 1955
Gouache and ink on paper, 50 × 74
Private collection

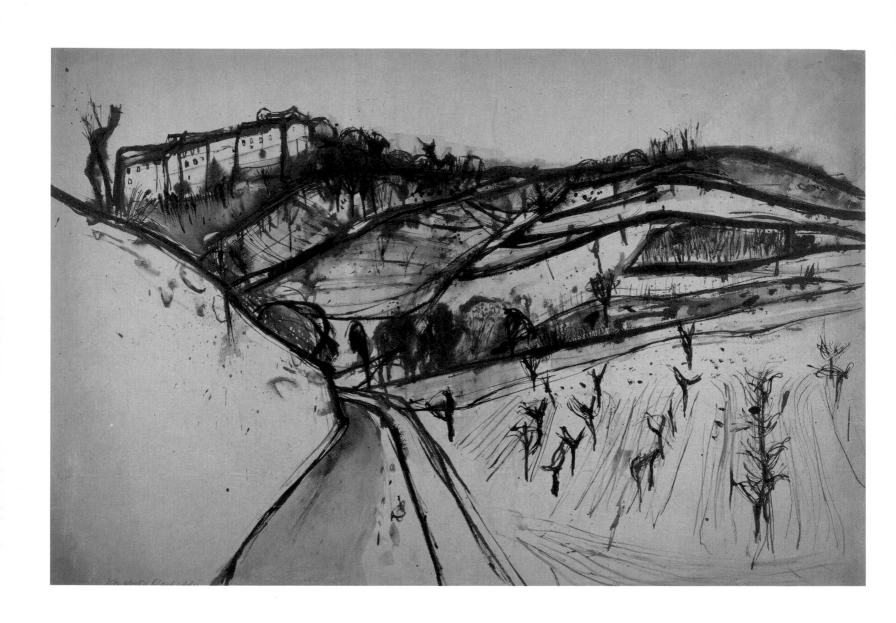

7 Impruneta, 1956

Ink on paper, 50 × 74
Edinburgh City Art Centre

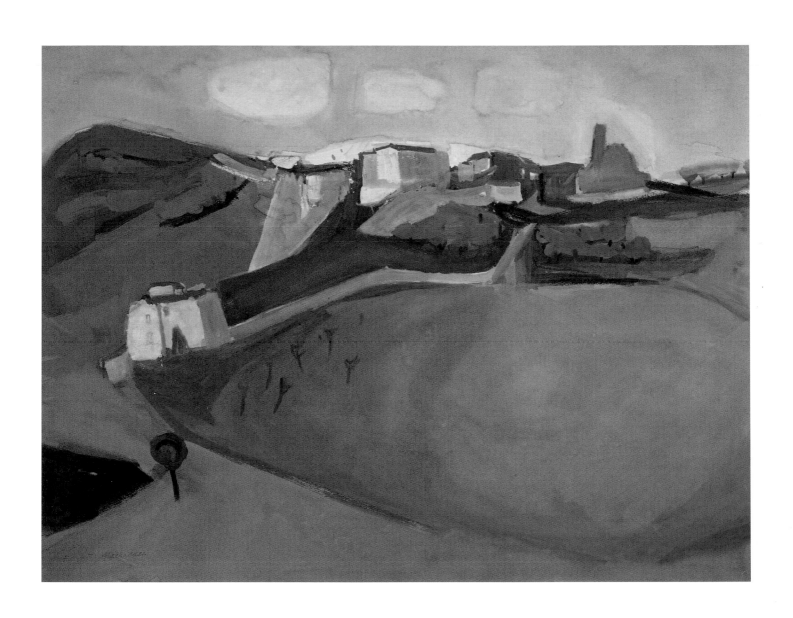

8 Tuscan Landscape, Impruneta, 1955–6

Watercolour on paper, 50 × 68
Dr Angus Gibson Gift, 2002
Scottish National Gallery of Modern Art, Edinburgh

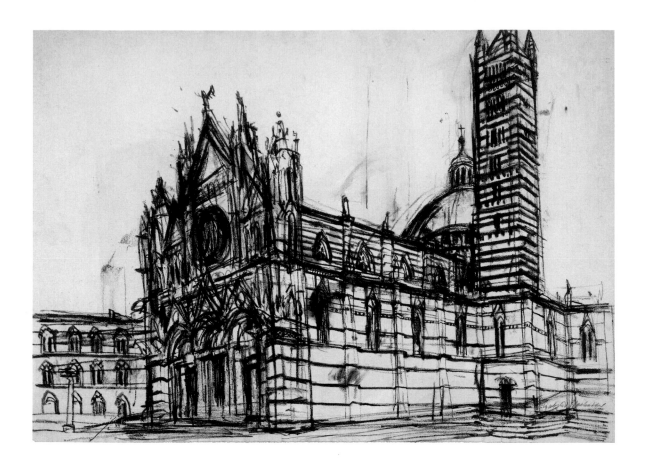

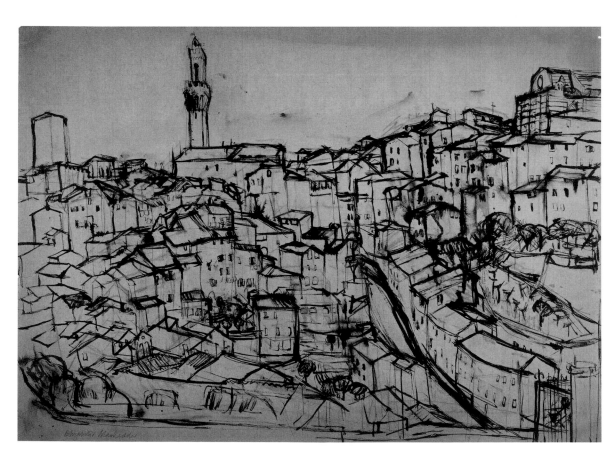

9 View of the Duomo, Siena, 1955
Pastel on paper, 47 × 66
Private collection

10 Siena, 1956
Ink on paper, 51 × 69
Edinburgh City Art Centre

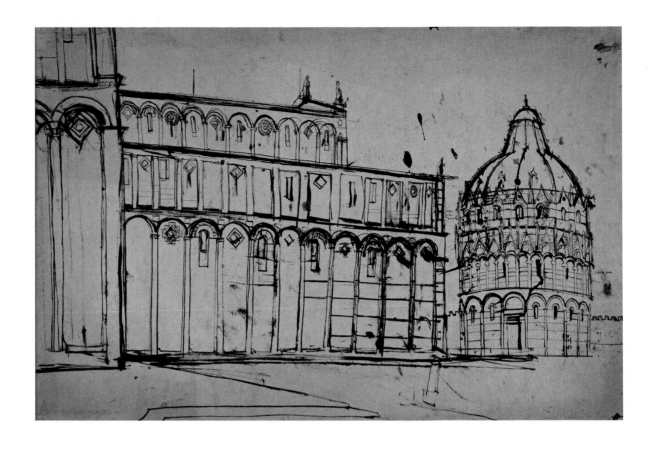

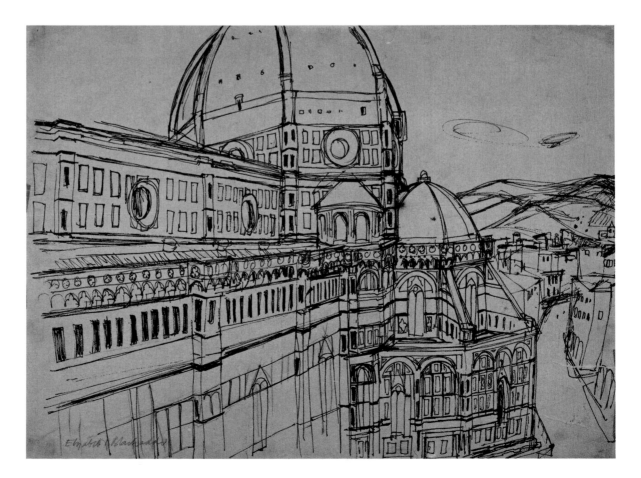

11 Baptistry, Pisa, 1956

Ink on paper, 56 × 76
Private collection

12 The Duomo, Florence, 1955

Ink on paper, 33 × 46
Private collection

Elizabeth Blackadder
establishing a career

Blackadder returned from Italy to Edinburgh in the spring of 1956. That summer, she and John married and they moved into a flat at 7 London Street in Edinburgh's New Town, on the same stair as Anne Redpath, who was already known to them personally through their friendship with her son, David Michie. By this time John had begun teaching at Edinburgh College of Art, and in the year of their marriage Elizabeth too was appointed as a lecturer, then a common practice that helped the college's most able graduates through the challenging transitory period from student to professional artist. The post was part-time for two years, following which Blackadder undertook teacher training at Edinburgh's Moray House. She taught briefly at St Thomas of Aquin's School in 1959, until she was asked by Professor Talbot Rice to become librarian at the Fine Art Department of the University of Edinburgh, a position she held until 1962.

For young artists such as Blackadder and Houston, Edinburgh in the years around 1960 was a place of limited but developing opportunities. The art college represented a close-knit and mutually supportive community, led by senior figures such as William Gillies and William MacTaggart who were successful as exhibiting artists in their own right. Around them a new generation of teachers such as Robin Philipson were in works such as *Burning at the Sea's Edge* introducing new, more physical means of expression informed by a greater awareness of

contemporary international developments. The Edinburgh International Festival had, since its inception following the Second World War, organised an outstanding series of exhibitions on subjects such as Cézanne, Renoir, and Byzantine art, as well as on the modern master Jacob Epstein. Around the same time institutions such as the Scottish Society of Artists were active in introducing avant-garde work to their annual exhibitions. In 1956, for example, the Society included a memorial display of over twenty works by the Russian/French artist Nicolas de Staël, which John Houston helped to organise. De Staël's powerful abstract compositions, which used a medium thickly applied in fractured, brilliantly coloured forms, made a considerable impact on Scottish artistic sensibilities, including those of Elizabeth Blackadder.

In 1955 her work was exhibited for the first time at the pre-eminent Royal Scottish Academy, but substantial exhibiting opportunities for young local artists were few. The city's one commercial gallery, The Scottish Gallery, with its premises in Castle Street, was naturally reluctant to make substantial commitment to untested talent, but was able to offer representation in group shows. The foundation of the 57 Gallery by a group of local artists (named after the year in which it was set up, 1957) was an important step – in particular for Blackadder, whose first solo exhibition was held there in 1959, at its small premises on a first floor in George Street. At around the same time the Scottish Committee

of the Arts Council of Great Britain had come into being and was developing opportunities for younger artists. Encouraged by Anne Redpath, the committee offered to subsidise the production of lithographs by artists who would work with the commercial lithographers, the Harley Brothers. As a Fine Art student, printmaking had not been readily available to Blackadder during her student years, but she was one of the first to be selected to collaborate with the printmakers, producing three editioned lithographs at their premises in St James's Square.[1] Deriving from her scholarship in Italy, the print *Tuscan Landscape* [14] has the same graphic strength of the drawings she had made there, but with the added dimension of a printed mauve wash. In *San Martino, Lucca* [15], there is less of a distinction between what might be described as structural drawing and accompanying colour, and the consequence is a more painterly overall approach. To this Blackadder adds a sense of episode through the inclusion of a dark rider on a white horse.

Through the Harley experience, Blackadder met Robert Erskine, who from the late 1950s was a champion of artists' printmaking in Britain. Erskine's establishment of the Curwen Press in east London did much to promote printmaking among artists, and Blackadder was invited to work there. She produced her first two Curwen prints, *Fifeshire Farm* [22] and *Dark Hill, Fifeshire* [23], at the studio in 1960, the latter part of a commission for the Museum of Modern Art in New York. Both prints, also lithographs, continued

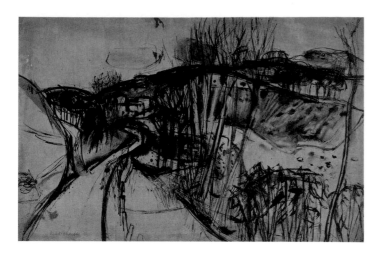

13 Tuscan Landscape, 1955
Ink on paper, 47.5 × 73
Private collection

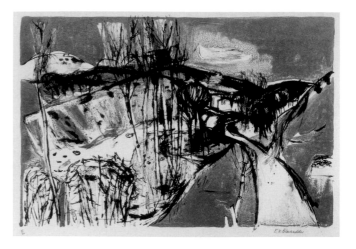

14 Tuscan Landscape, 1958
Lithograph on paper, 53.5 × 74
Scottish National Gallery of Modern Art, Edinburgh

Blackadder's preoccupation with depicting the wintry landscape, the skeletal forms of the hedgerows and trees well suited to Blackadder's explorative cursive line and use of dark, inky forms.

In the same year, 1960, Houston held the first of many exhibitions at The Scottish Gallery, and from the proceeds bought a car, a Hillman Minx, which enabled the couple to drive to France: to Normandy and Brittany. Up to this point Blackadder's work had been predominantly graphic, but from around this time she began to produce oil paintings, such as *Church at Treguer* (private collection), painted after that visit. Others followed, such as *Wall Town* [19], painted from the Northumbrian landscape, and *Church in Brittany* [26], from a further trip to France in 1963. Like the small lithograph of San Martino, in which an anonymous figure appears, framed by the arches of the church's façade, in the oil painting, *Church at Tregeur,* the white wimple of the worshipper and the accompanying blaze from devotional candles adds light and interest to the sombre architectural setting. Blackadder would have been aware of Anne Redpath's paintings of church interiors, which used to great effect passages of brilliant colour. This had been a long-standing technique in Redpath's work, but her use of it grew bolder from the late 1950s onwards, partly as a consequence of seeing the work of such artists as De Staël, and she applied it with dramatic effect in still-life paintings such as *Tulips* of around 1962.

By that point Blackadder's interest in still-life painting had already revived. In 1962 she was appointed as a full-time lecturer at Edinburgh College of Art (a position in which she would continue until 1986), and still life as a subject allowed her to return to and work steadily on a composition, as and when her busy teaching commitments permitted. Blackadder quickly appreciated the potential of still life as an exciting subject; that it was 'not about painting different objects, but painting the relationship between objects in space'.[2] Such a sensibility was strong among Edinburgh-based artists. Towards the end of his life Samuel John Peploe, one of the Scottish Colourists, noted: 'There is so much in mere objects, flowers, leaves and jugs – colours, forms, relations – I can never see mystery coming to an end.'[3] That was in the 1930s, when Peploe taught briefly at Edinburgh College of Art and made a lasting impression on young tutors in Peploe's time such as Gillies, MacTaggart and John Maxwell, who would go on to instruct Blackadder and her generation. Peploe's maxim seems well suited to Blackadder's ethos. Using the subject of still life, for half a century now, she has explored continuously the nature of things and how they relate to each other. This is done in a manner that, depending on medium or approach, moves between scientific analysis and pictorial freedom, but always keeps the essence of the observed thing at heart.

In 1962 Blackadder exhibited *White Still Life, Easter*

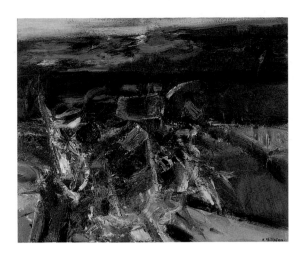

Robin Philipson, *Burning at the Sea's Edge*, c.1961
Scott Hay Collection: presented 1967
Scottish National Gallery of Modern Art, Edinburgh

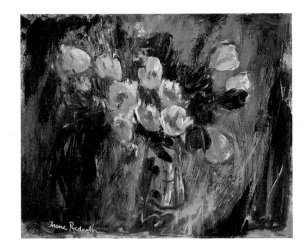

Anne Redpath, *Tulips*, c.1962
Scott Hay Collection: presented 1967
Scottish National Gallery of Modern Art, Edinburgh

(private collection) at the Royal Scottish Academy. This work received the Guthrie Award, which was presented annually to the most promising young artist. The following year John received the award, and at the same time Elizabeth was elected an Associate of the Academy; clear indications of the serious impression this young couple were now making on the Edinburgh art world. Elizabeth too had begun to exhibit at The Scottish Gallery, and shortly afterwards she came to the attention of Gillian Raffles, whose Mercury Gallery in London was to become an important promoter of Blackadder's art from 1965 onwards. In the year when Elizabeth won the Guthrie Award, she and John returned to Greece, visiting pre-Hellenistic sites and Byzantine churches. In paintings of Mykonos and Mistra [24 & 25] she experiments with watercolour on a large scale, using saturated, glowing colour. A further trip to France resulted in ambitious oils such as *View to a Garden, Vence* [28], which combines a dark interior and shadowed figure with a view to the lush and brilliant outdoors, a composition that illustrates Blackadder's interest, common to other British artists of the time, in exploring how a figure might be shown to occupy a room.

In 1963, Elizabeth and John moved from London Street to Queen's Crescent on the south side of Edinburgh and in her new studio there she concentrated chiefly on still life in oil. In the series of works produced over the next few years, Blackadder experimented with approaches that vary from

table-top arrangements such as *Still Life with Grey Table* of 1965 [30], composed and painted in a manner that recalls Gillies, to more radical compositions such as *Portuguese Still Life* [32] of the following year. Here, in a composition that may have had its origins in a boldly patterned scarf, the geometric forms of the border suggest Blackadder's receptiveness to the strident colouring and playfulness of British Pop and Op(tical) Art. The artist's experimentation also included the use of different media, such as the exuberant *Flowers on an Indian Cloth* [31], executed in 1965 in oil crayon. As the end of the decade approached, works such as *Still Life with Silk Scarf* [34] utilised pictorial borders, a rich vocabulary of forms and vivid colour harmonies, all within the bounds of one composition. While acknowledging the tradition from which she came, Blackadder's multiplicity of approach indicates she was striving to find a new way of working and her own distinct artistic voice.

1. The third editioned lithograph produced by Blackadder at Harley Brothers was *Harlequin*. A further was produced, *Chamber Music*, but not editioned. For details see *Artists at Harleys – Pioneering Printmaking in the 1950s*, Hunterian Art Gallery, University of Glasgow, 2000.

2. Life story recording: Elizabeth Blackadder interviewed by Jenny Simmons, 2006, *Artists' Lives*, National Life Stories © British Library, catalogue reference C466/239/01–07

3. S.J. Peploe, quoted in Philip Long and Elizabeth Cumming, *The Scottish Colourists 1900–1930*, exhibition catalogue, National Galleries of Scotland, 2000, p.38.

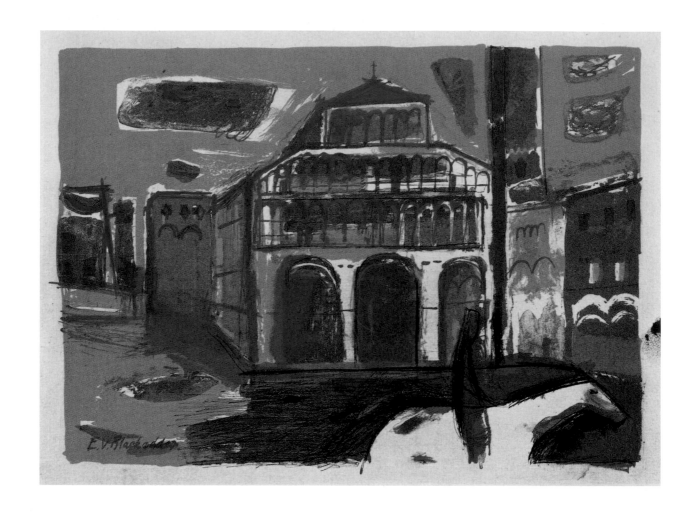

15 San Martino, Lucca, 1958

Lithograph on paper, 21.7 × 30.7
Private collection

16 Altar, Lucca, *c.*1961

Oil on canvas, 80 × 60
Private collection

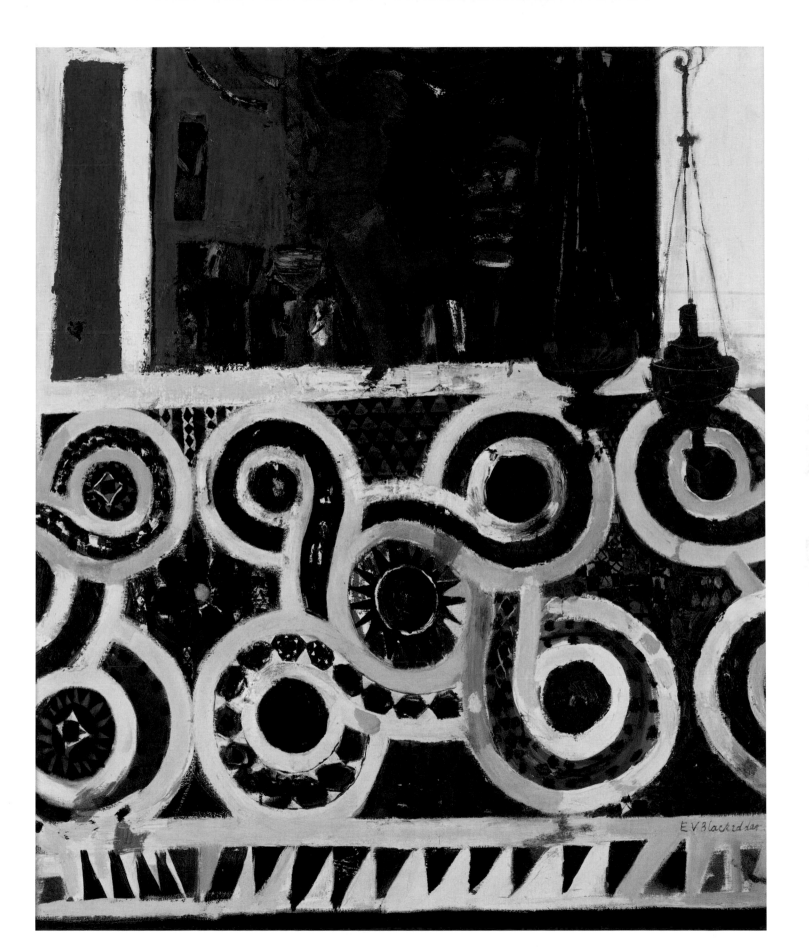

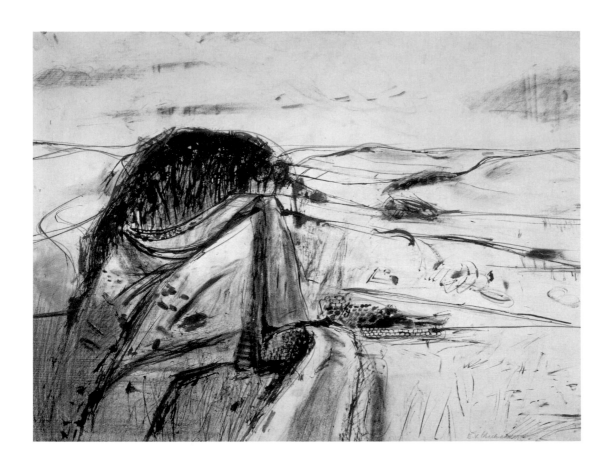

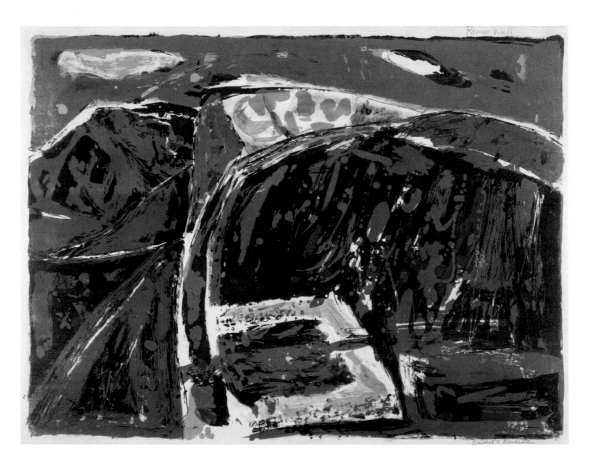

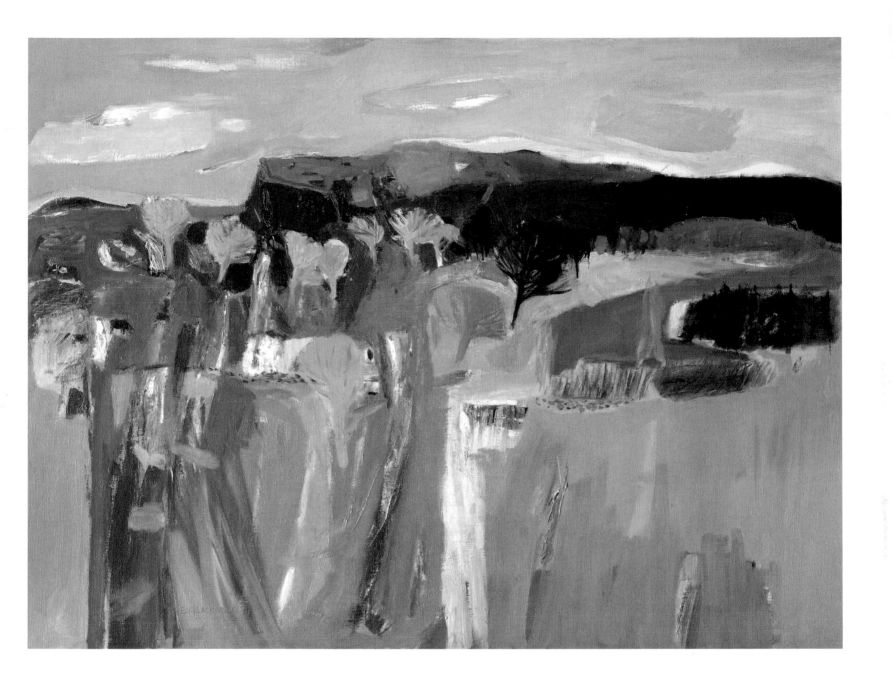

17 Housesteads, Hadrian's Wall, *c*.1960–1

Ink, black chalk and pencil on paper, 51 × 66.5
Bequeathed by Dr R.A. Lillie, 1977
Scottish National Gallery of Modern Art, Edinburgh

18 Roman Wall I: Castle Nick, 1963

Lithograph on paper, 57 × 72
Presented by Mr and Mrs J. Doyle, 2006
Scottish National Gallery of Modern Art, Edinburgh

19 Wall Town, 1961

Oil on canvas, 85 × 111
The University of Edinburgh Fine Art Collection

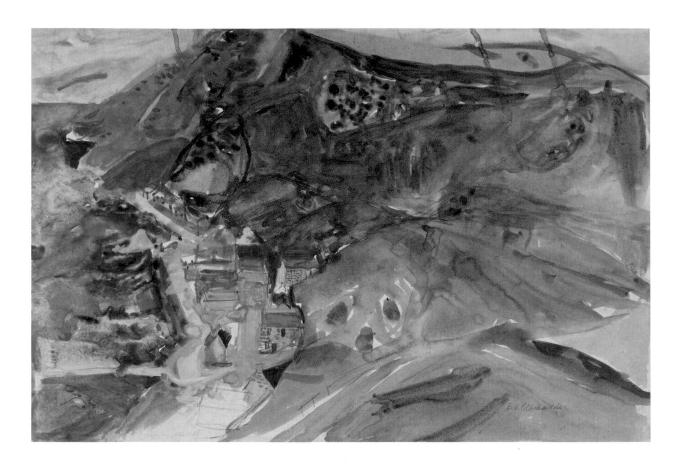

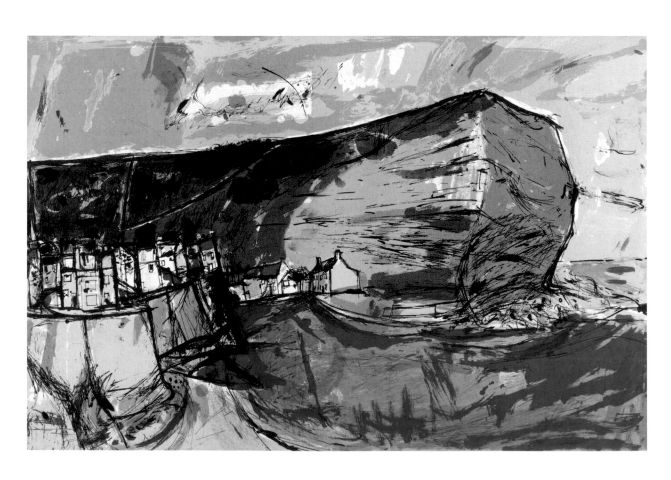

20 Crovie, 1961–3
Watercolour and pencil on paper,
36.2 × 53.6
Bequeathed by Dr R.A. Lillie, 1977
Scottish National Gallery of Modern
Art, Edinburgh

21 Staithes, 1962
Lithograph on paper, 52.1 × 87.7
Private collection

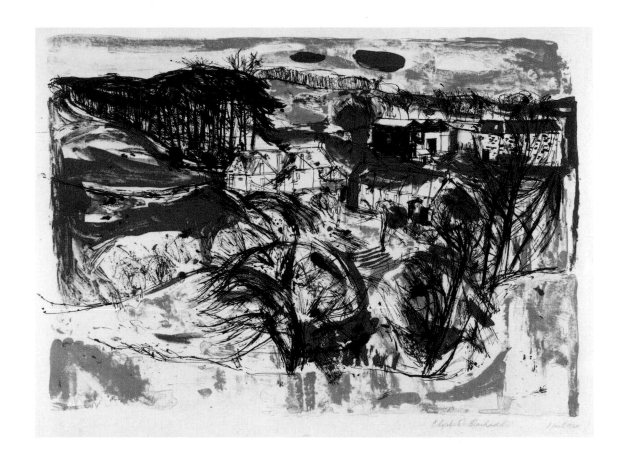

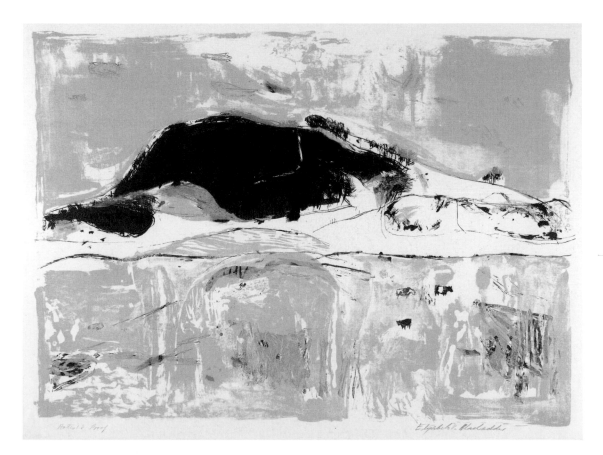

22 Fifeshire Farm, 1960

Lithograph on paper, 47.6 × 67.6
Private collection

23 Dark Hill, Fifeshire, 1960

Lithograph on paper, 57 × 79.4
Scottish National Gallery of Modern Art,
Edinburgh

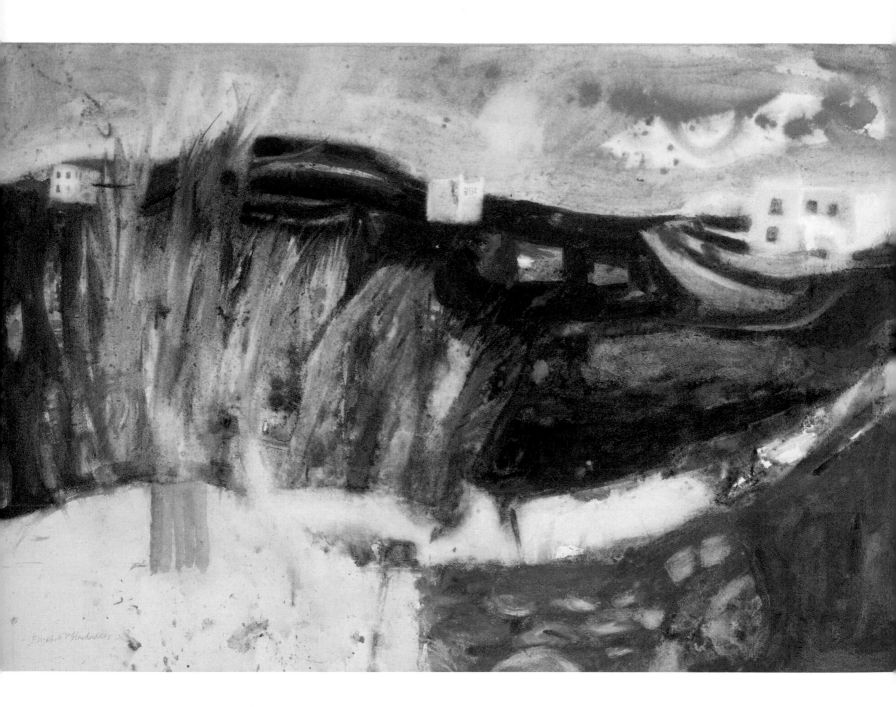

24 House and Fields, Mykonos, 1962

Watercolour on paper, 70 × 102.5
Gulbenkian UK Trust Fund, 1963
Scottish National Gallery of Modern Art, Edinburgh

25 Façade, Mistra, 1963

Watercolour on paper, 69 × 80
Edinburgh City Art Centre

26 Church in Brittany, 1963

Oil on canvas, 76 × 102
Private collection

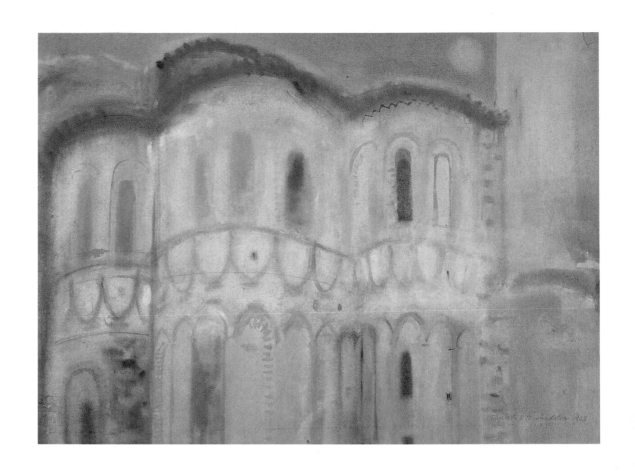

27 Garden, Vence, 1966

Ink on paper, 25.2 × 35.4
Bequeathed by Keith Andrews, 1990
Scottish National Gallery of Modern Art, Edinburgh

28 View to a Garden, Vence, 1966

Oil on canvas, 110 × 82
Private collection

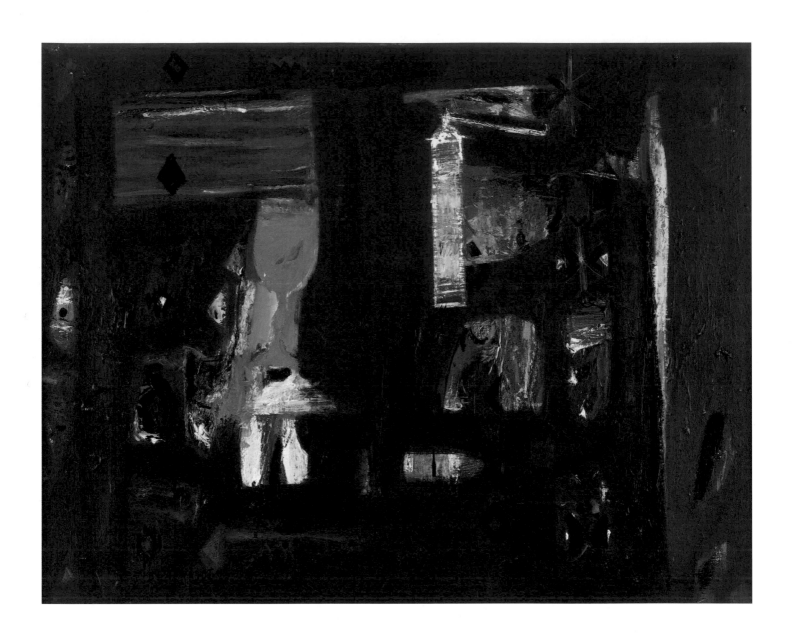

29 Still Life with Turkish Coffee Mill, 1964

Oil on canvas, 61 × 76

Private collection

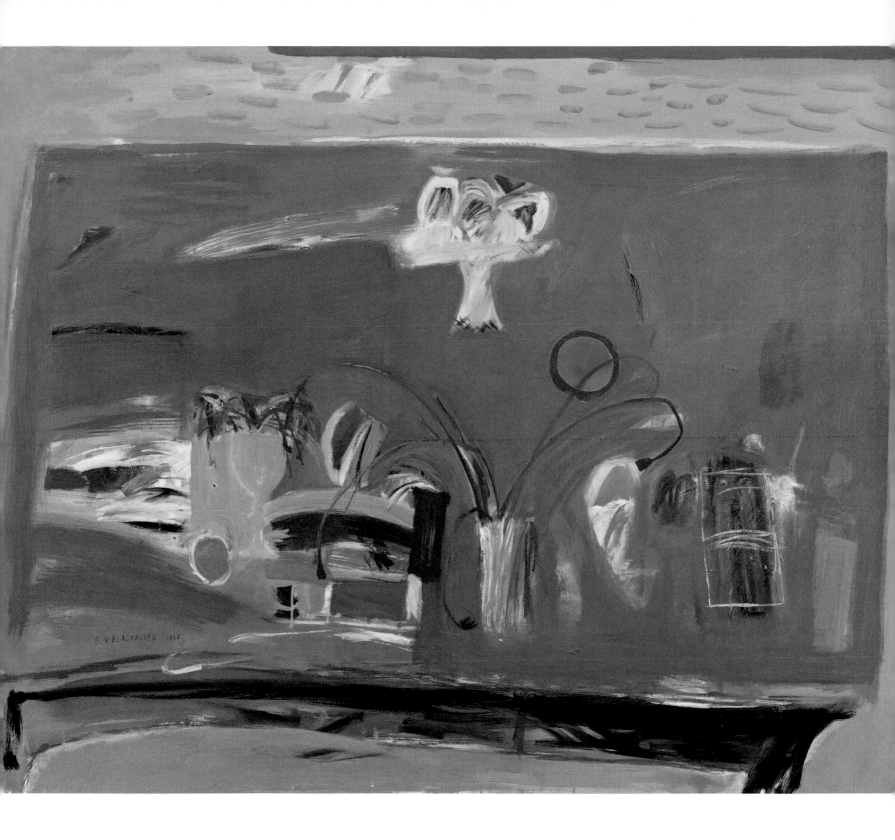

30 **Still Life with Grey Table,** 1965
Oil on canvas, 102 × 71
Private collection

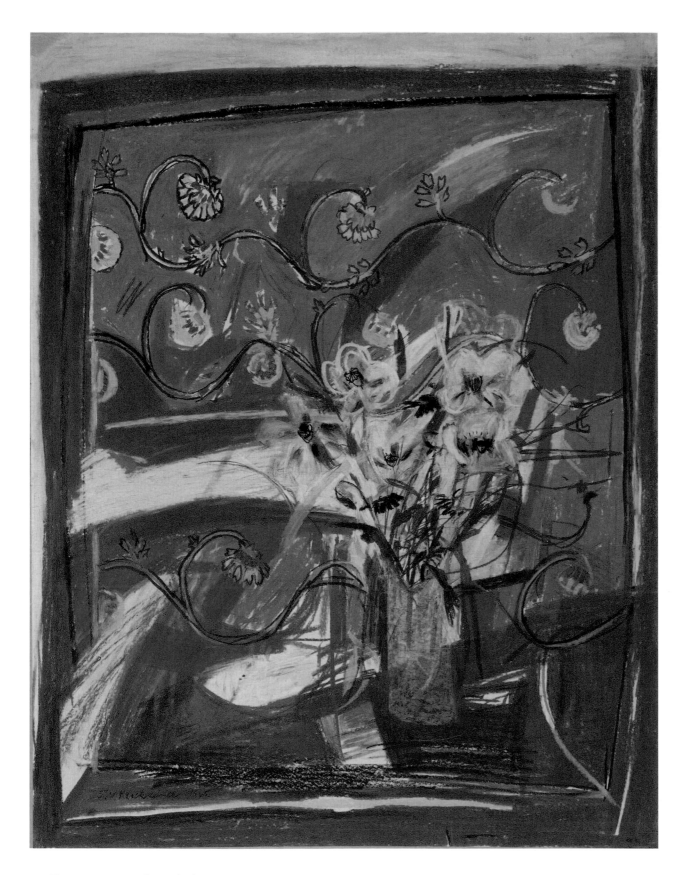

31 Flowers on an Indian Cloth, 1965

Oil crayon on paper, 102 × 77

Scott Hay Collection: presented 1967. Scottish National Gallery of Modern Art, Edinburgh

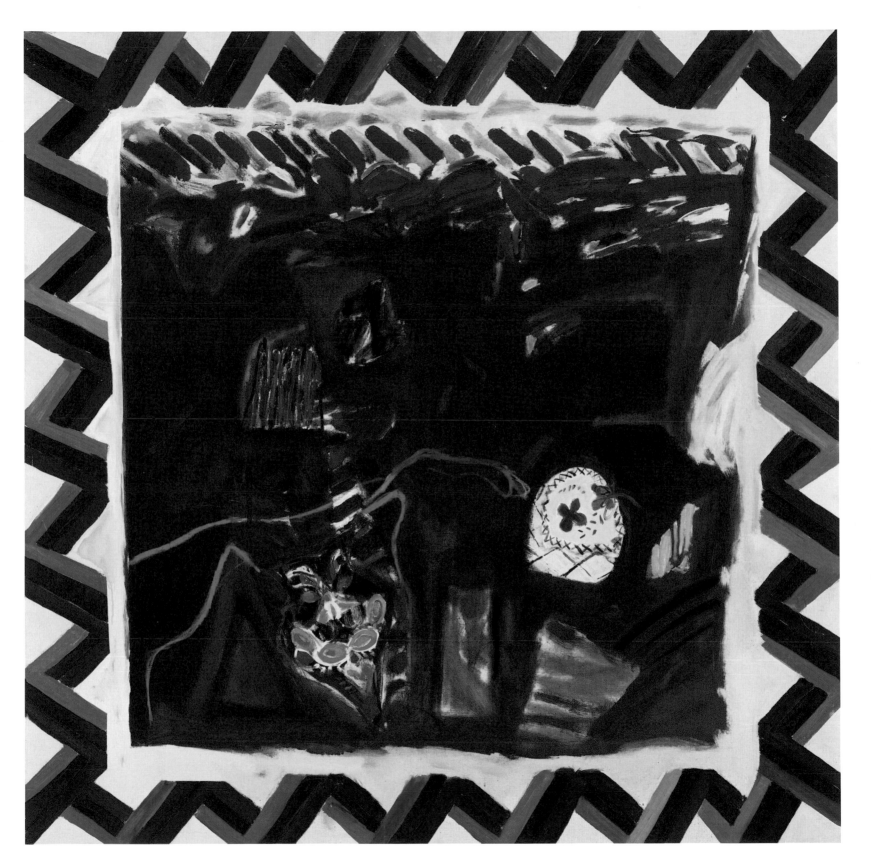

32 Portuguese Still Life, 1966

Oil on canvas, 112 × 112

Private collection

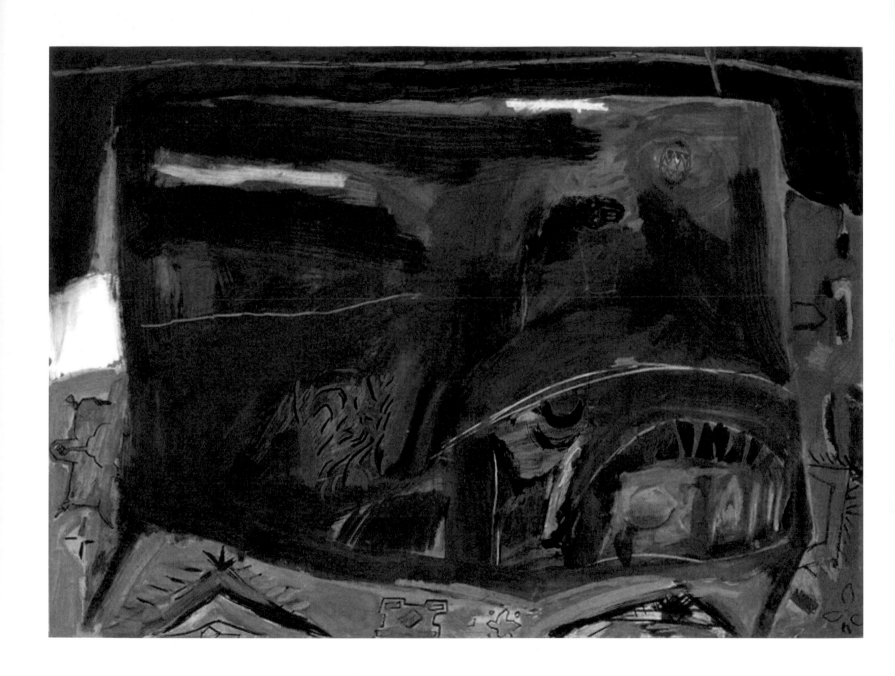

33 Grey Table with Easter Eggs, 1966

Oil on canvas, 83.2 × 115.5

Aberdeen Art Gallery & Museums Collections

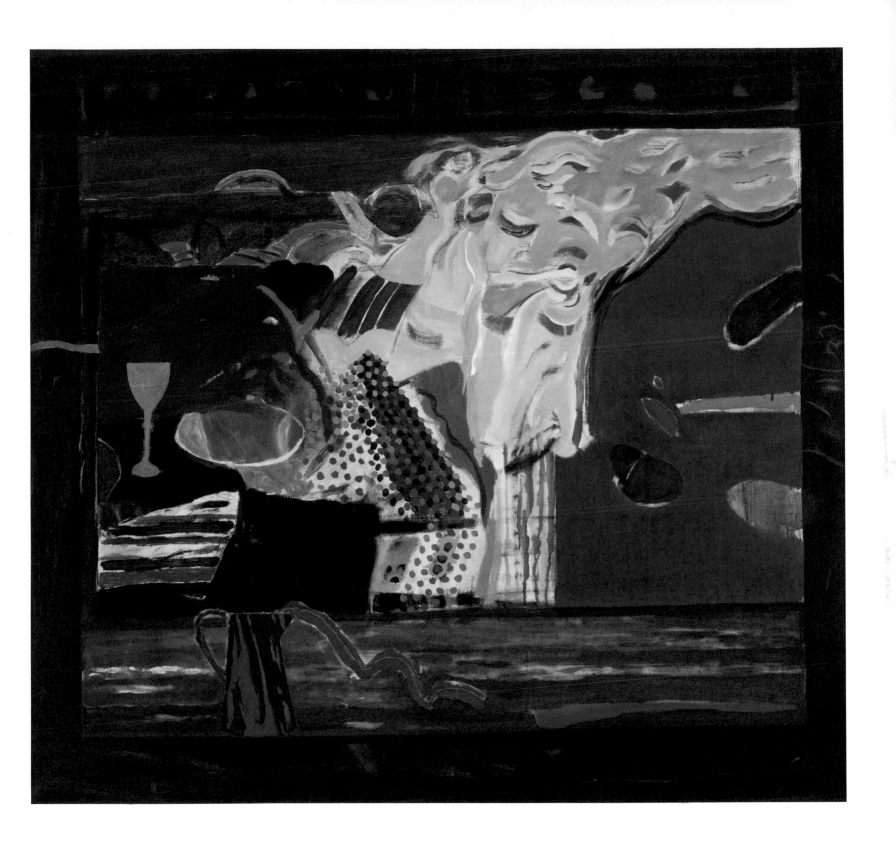

34 Still Life with Silk Scarf, 1968

Oil on canvas, 101.5 × 112

Private collection

Elizabeth Blackadder

oil painting since the late 1960s

Detail from *Indian Still Life with Ball and Bird*, 1974 [36]

In 1969 Blackadder's husband, John Houston, was invited by collectors of his work to paint the landscape of Wisconsin in the United States, and Elizabeth accompanied him. On the way out they stopped in New York, visiting the Museum of Modern Art and the Guggenheim Collection, where they paid special attention to the works of Matisse and Picasso. They passed through Manhattan on their return, and saw a major exhibition of twentieth-century American painting that included a strong representation of post-war abstract art by Jasper Johns, Willem de Kooning and others. Such experiences undoubtedly suggested possibilities to Blackadder, an artist whose work to that date clearly demonstrated receptiveness to new ideas and interest in working in experimental modes. Although Elizabeth painted little while in the United States (she recollects she was kept busy stretching canvases for John), the scale and character of her work notably evolved upon her return in 1969.

For Blackadder still life has been not so much about depicting individual objects, but about representing their interrelationships in space, and a major preoccupation for the artist, from the 1960s, was just how to express that space. Works such as *Grey Table with Easter Eggs* [33] retain, in the Edinburgh School tradition, a clear indication of the form of the table, with the top raised up towards the picture plain to give the fullest view. *Still Life with Turkish Coffee Mill* of 1964 [29] dispenses with this perspective,

however, and instead the surface of the canvas itself is treated as the field on which objects appear. Other experiences that contributed to the development of Blackadder's art at the time included, in particular, an exhibition of Indian Mughal painting (a style of miniature painting, which flourished throughout the Indian Mughal Empire from the sixteenth to the nineteenth century) which was held at the 57 Gallery in about 1968, brought together by the artist Howard Hodgkin. John and Elizabeth acquired two of these, impressed by the skill of the miniaturists in making works that combine intensity with sparseness, and the decorative with an illusion of space.

A characteristic of Mughal art is its use of borders, which began to appear in Blackadder's own work in the latter part of the 1960s. *Flowers and a Red Table* of 1969 [37] incorporates such a border; the table of the title is only evident by a regular strip of diluted ochre, which runs around the margins of the canvas, and defines the edge of the surface. What is markely different about this work, most likely painted after that trip to the United States, is the dominant field of unmodulated red. Along its bottom edge rests three items, only one of which, the jug of flowers, is clearly decipherable. In a subsequent picture, *Grey Table* of 1970–1 [38], the objects are subsumed to overall pictorial effect. Traces of a silk scarf, decorative box, ribbons and a jewelled bag remain, but become keynotes of form and colour within a grey background wash.

Such objects, however, form the crucial starting point for Blackadder's compositions (and do to this day), and their character and cultural origins, such as in *Indian Still Life with Ball and Bird* of 1974 [36] set the artist's overall approach. Fascinatingly, Blackadder's working processes do not involve a prearranged still life. Instead, she begins by seeing possibilities in an object, and sets about drawing or painting it. That object is then set aside and a further one added, and from this the composition develops intuitively.[1]

At the same time as Blackadder was using the motif of still life to develop compositions verging on the abstract, she was looking afresh at the subject of the interior. In practice, the artist does not see a separation between the use of differing motifs. Each one provides inspiration and presents a challenge as to how to explore the interrelationship of form and colour within two dimensions. Thus in *Interior with Self-portrait* of 1972 (private collection), our viewpoint tilts crazily as we look down on a gaily coloured rug and straight onto a chest of drawers. Blackadder's ease with colour and pattern, combined with her ability to balance rougher application of paint with unmodulated expanses of flat colour, creates a sense of lightness reminiscent of the relaxed interior scenes of contemporaries such as David Hockney.

In another series of works, Blackadder focused further on the interior. This approach followed Elizabeth and John's move to a larger home in Fountainhall Road in Edinburgh in 1975, which provided both with the greater studio space they desired, and a large garden. *Tulips and Indian Painting* [40] is one such interior scene. At its centre is a reflection of one of the couple's Indian miniatures, which is shown in a heavily framed mirror, surrounded by patterned wallpaper in the manner of Mughal decorative borders. Juxtaposed against the flower pattern of the wallpaper are two vases of 'real' flowers, except that one is not real in the sense that we see it in reflection only. *Self-portrait with Cat* [41] plays to a reverse effect, with pattern and portrait combined within the mirror frame, and a first appearance of the artist's beloved feline pets.

1. The artist in conversation with the author, May 2011

46

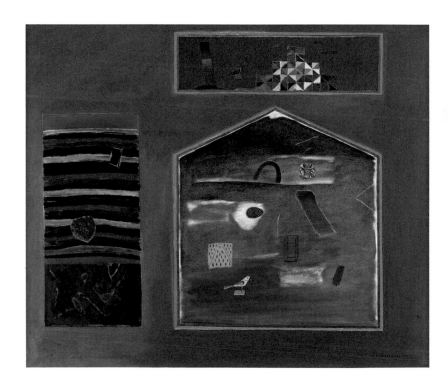

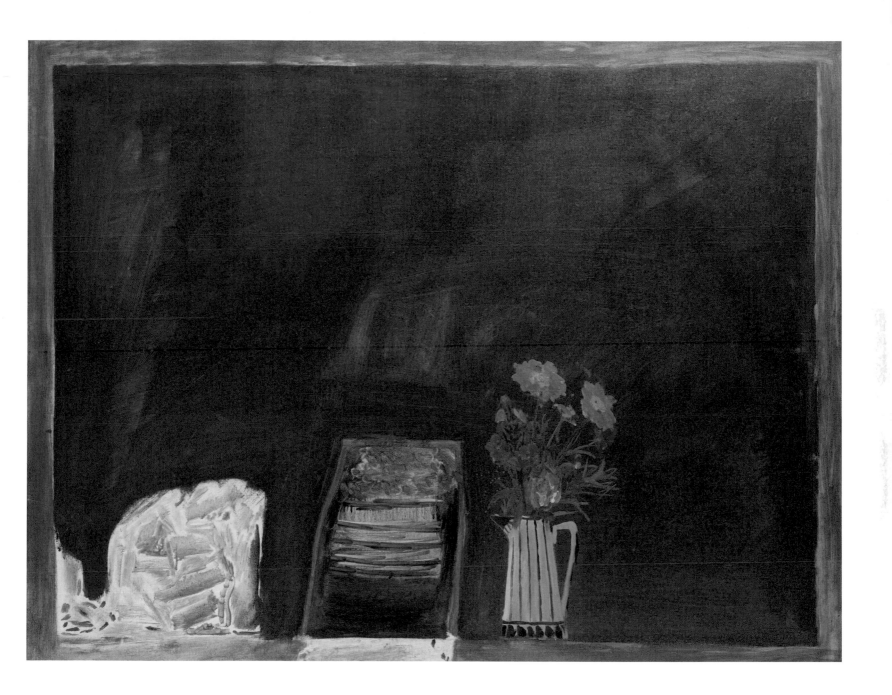

35 Church at Ericeira, 1969

Oil on canvas, 127 × 127
The Fleming-Wyfold Art Foundation

36 Indian Still Life with Ball and Bird, 1974

Oil on canvas, 101 × 129
Private collection

37 Flowers and a Red Table, 1969

Oil on canvas, 86.3 × 111.7
The Fleming-Wyfold Art Foundation

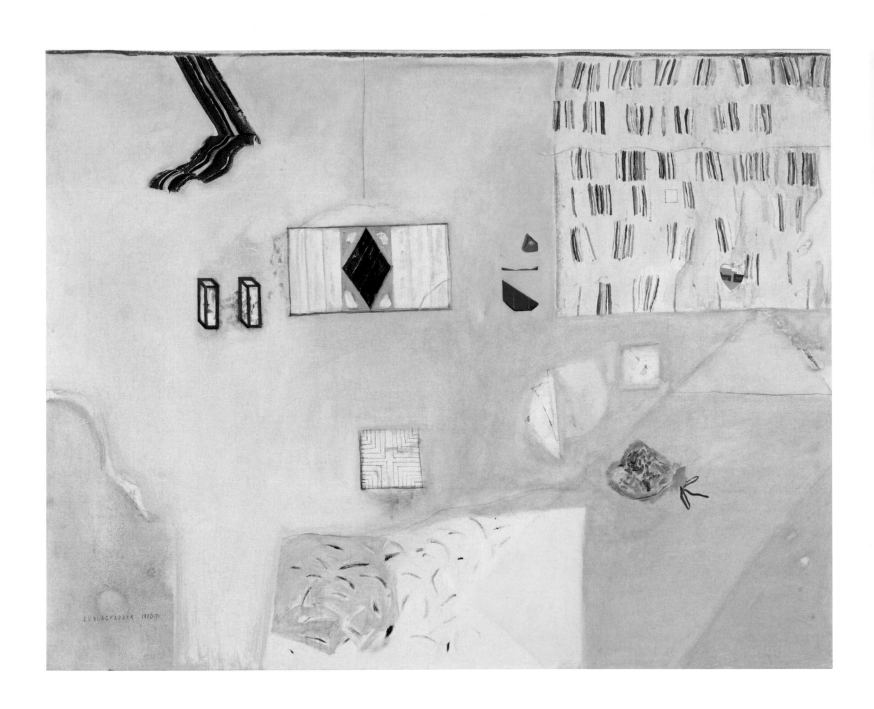

38 Grey Table, 1970–1

Oil on canvas, 111 × 142
Private collection

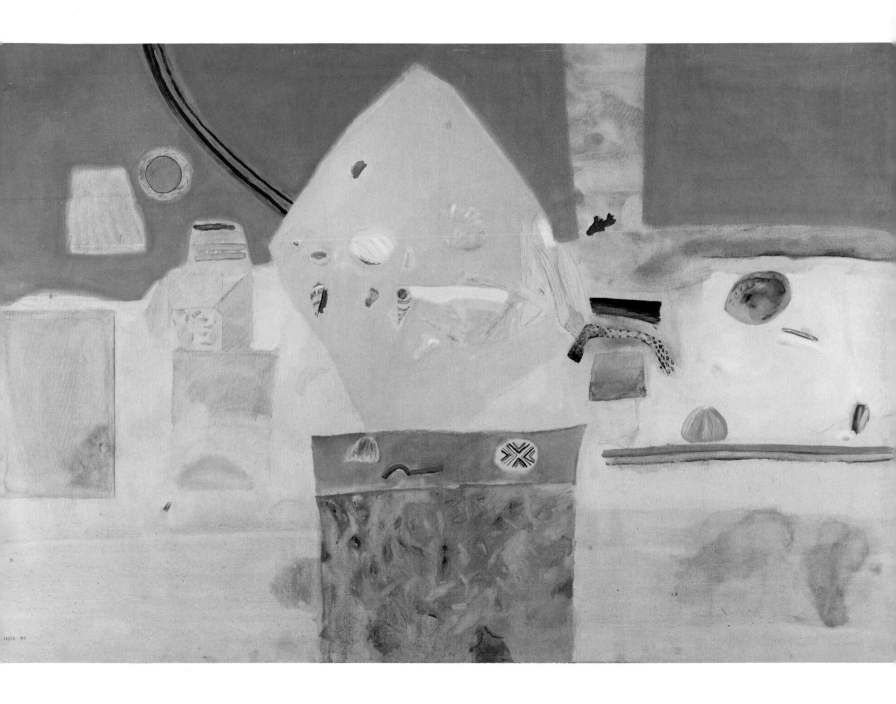

39 Still Life with Shells, 1971
Oil in canvas, 122 × 183
Private collection

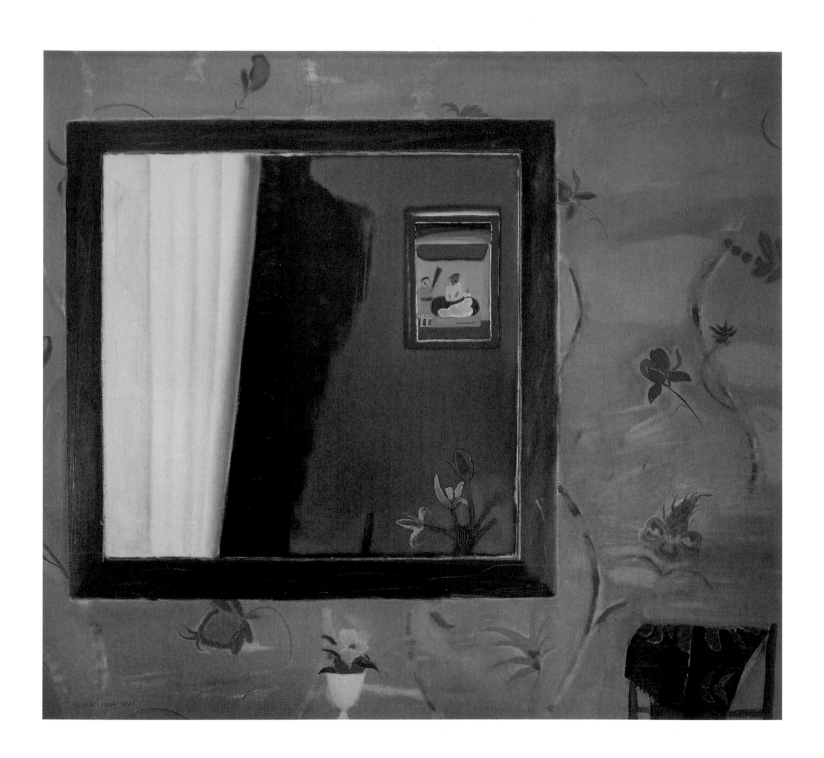

40 Tulips and Indian Painting, 1977

Oil on canvas, 90 × 90

Heriot Watt University Museum and Archive, Edinburgh

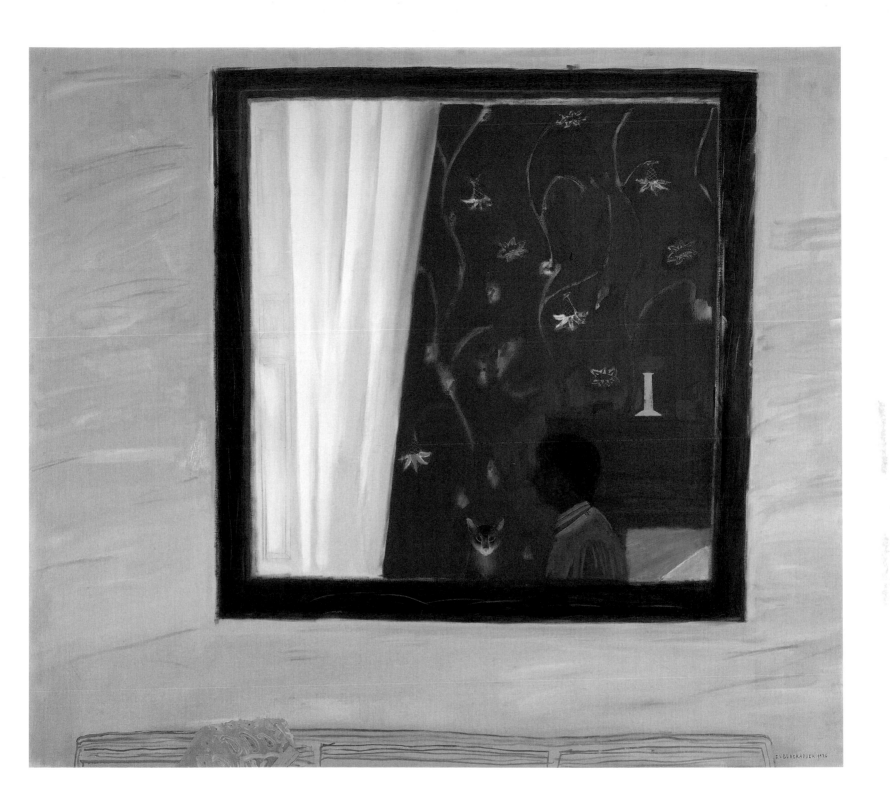

41 Self-portrait with Cat, 1976

Oil on canvas, 109 × 125
Royal Scottish Academy (Diploma Collection)

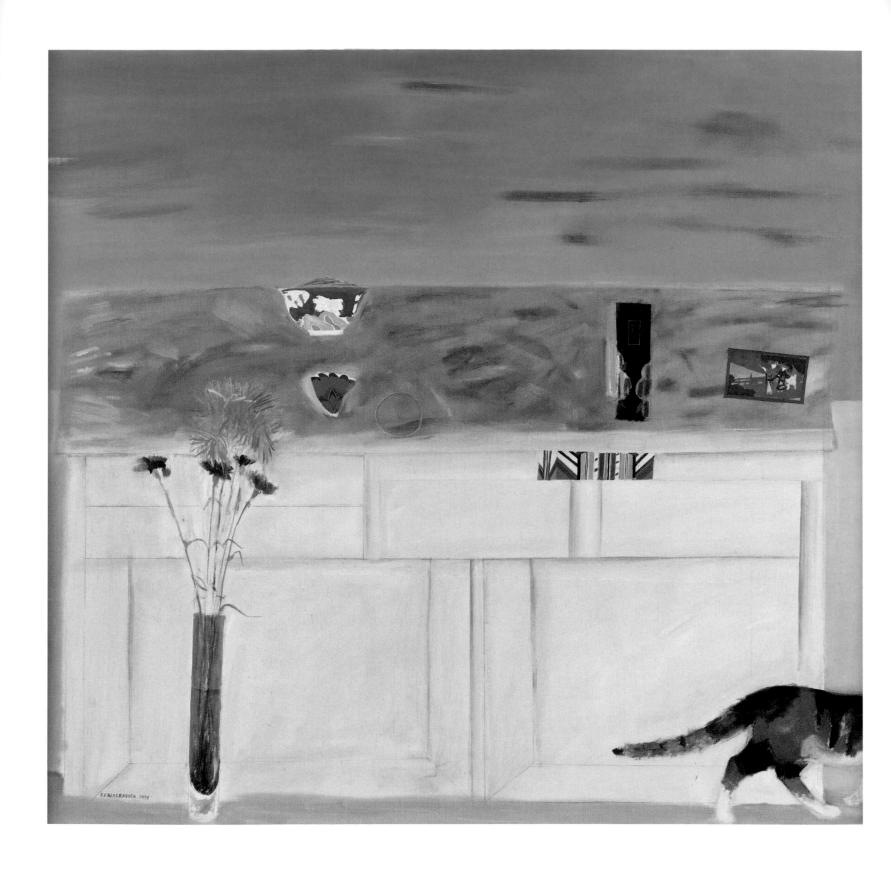

42 Coco and Cupboard, 1979

Oil on canvas, 122 × 122

Private collection

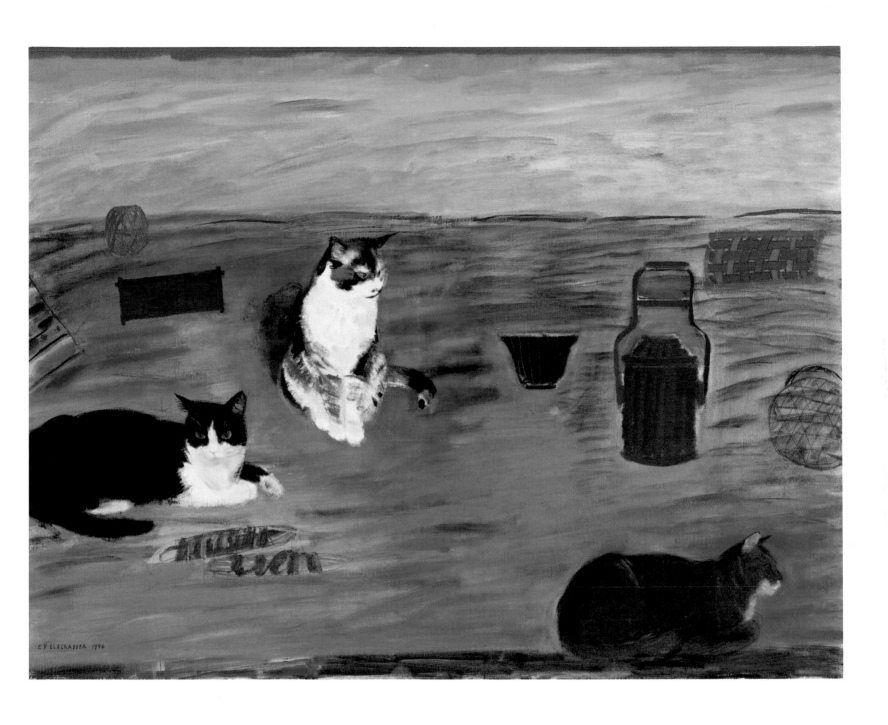

43 Still Life with Cats, 1991–4

Oil in canvas, 86 × 112

Private collection

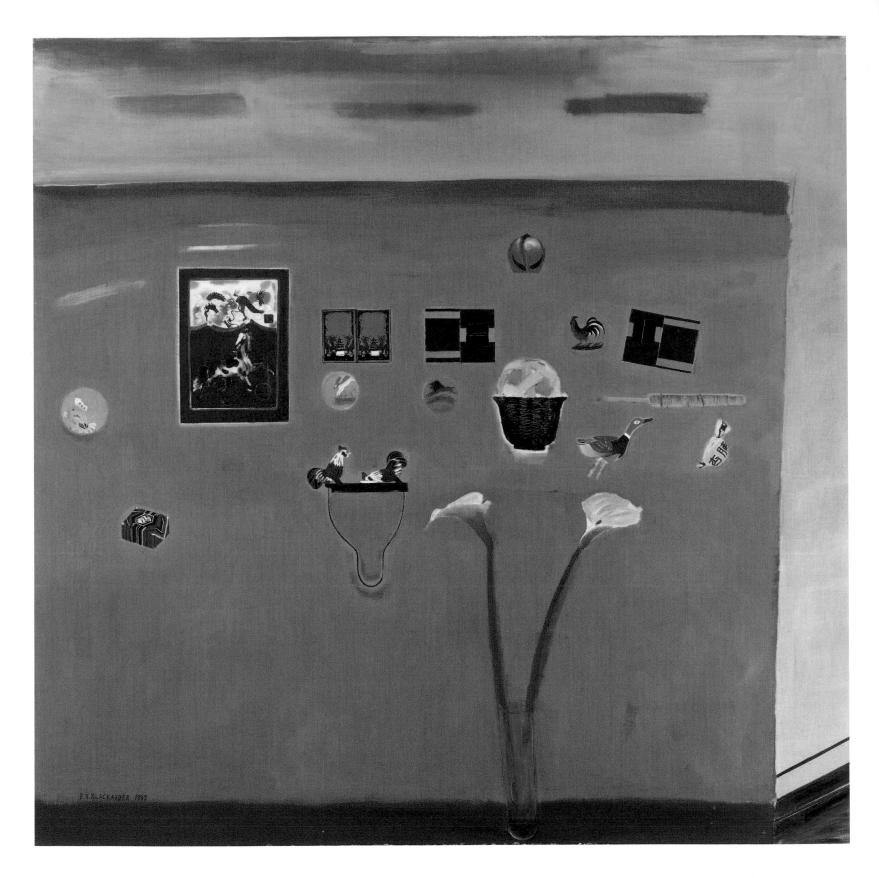

44 Chinese Still Life with Arum Lillies, 1982
Oil on canvas, 122 × 122
Private collection

45 Still Life with Mughal Drawing, 1993
Oil on canvas, 132 × 102
Private collection

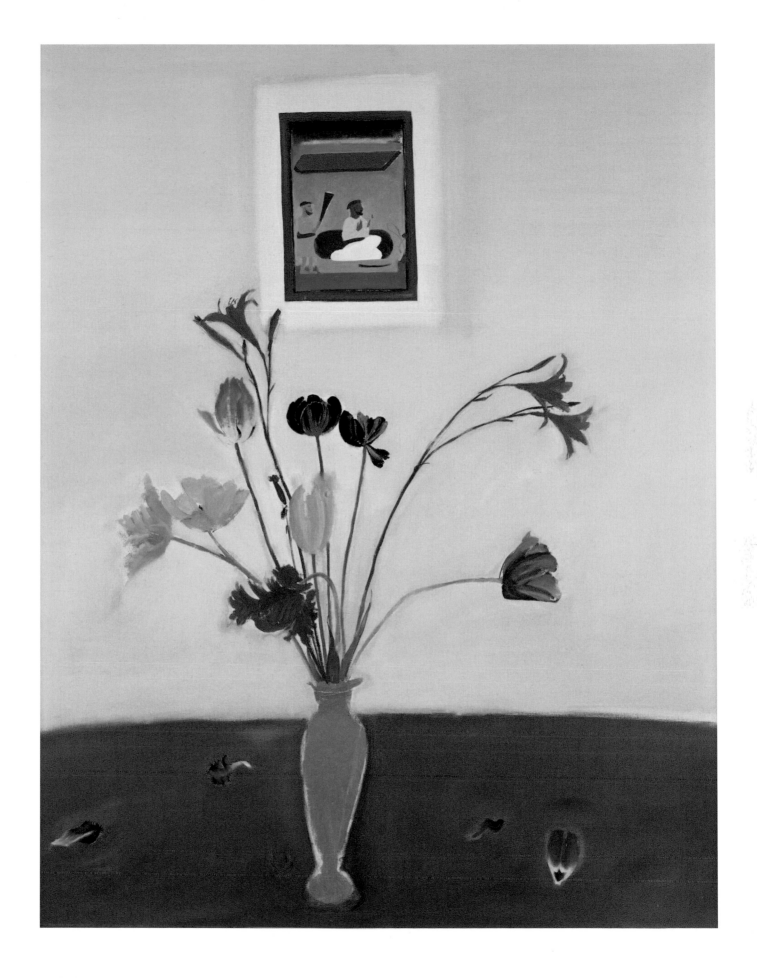

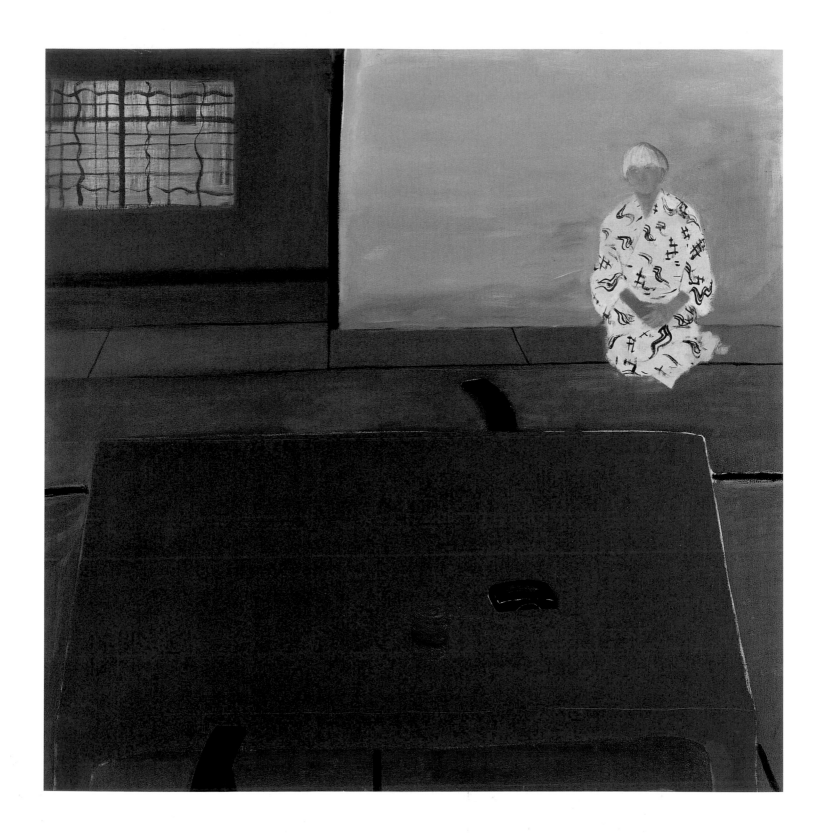

46 Self-portrait with Red Lacquer Table, 1988

Oil on canvas, 102 × 102

Private collection

47 Dark Pond, Alhambra, Granada, 1997

Oil on canvas, 154 × 154

Private collection

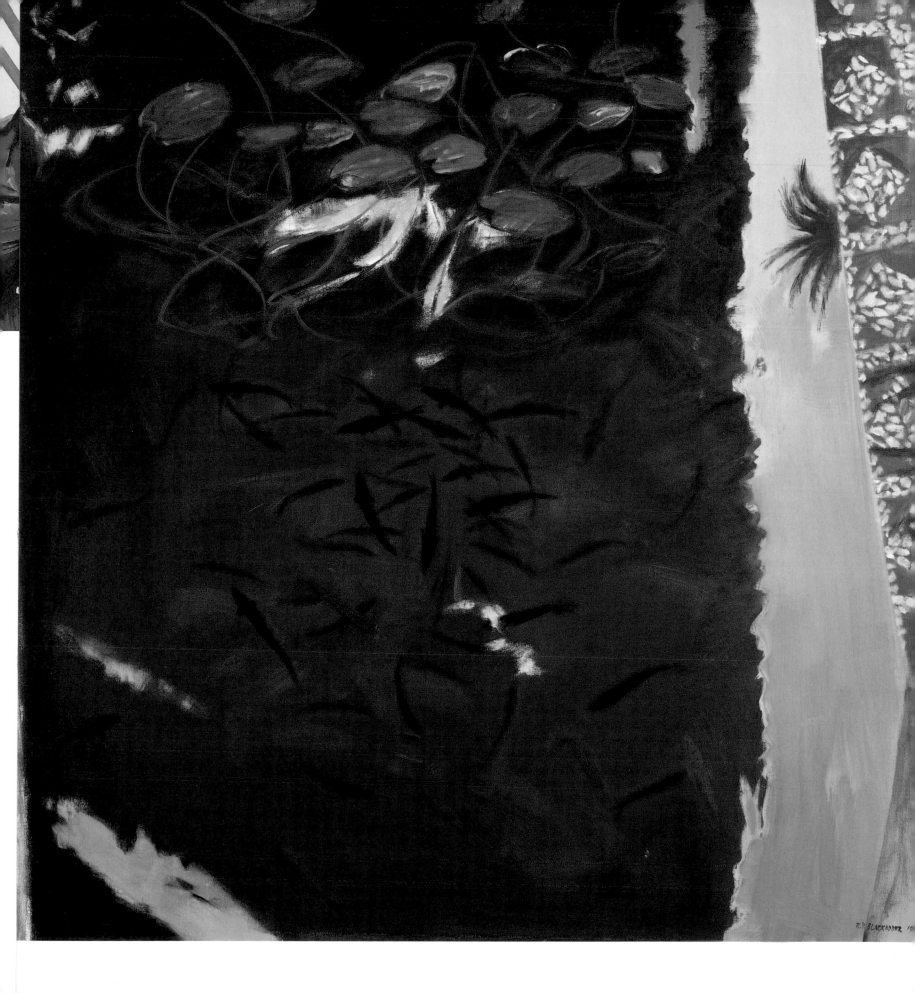

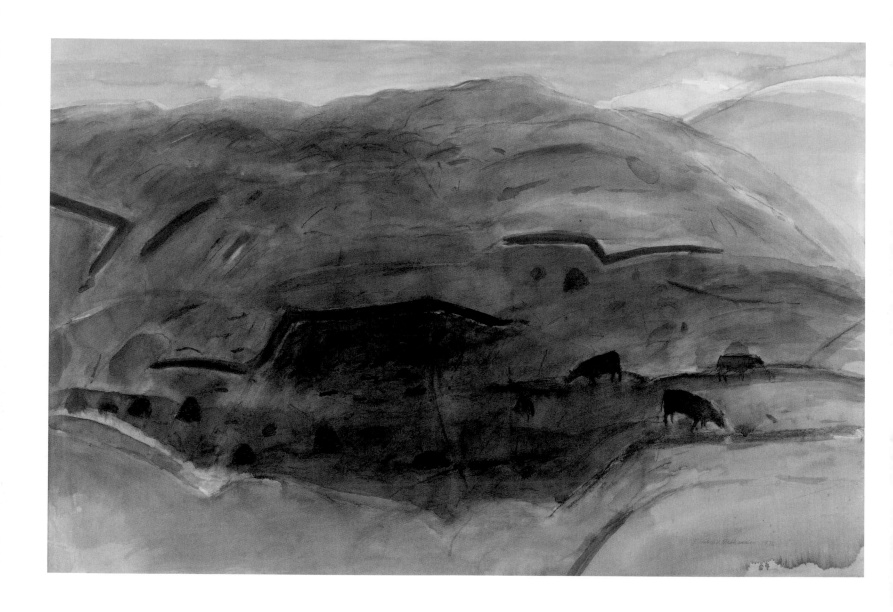

48 Peat Cuttings, Isle of Harris, 1976

Watercolour on paper, 67 × 103
Private collection

49 Scalpay, Looking towards the Shiant Isles, 1977

Oil on canvas, 91 × 102
Private collection

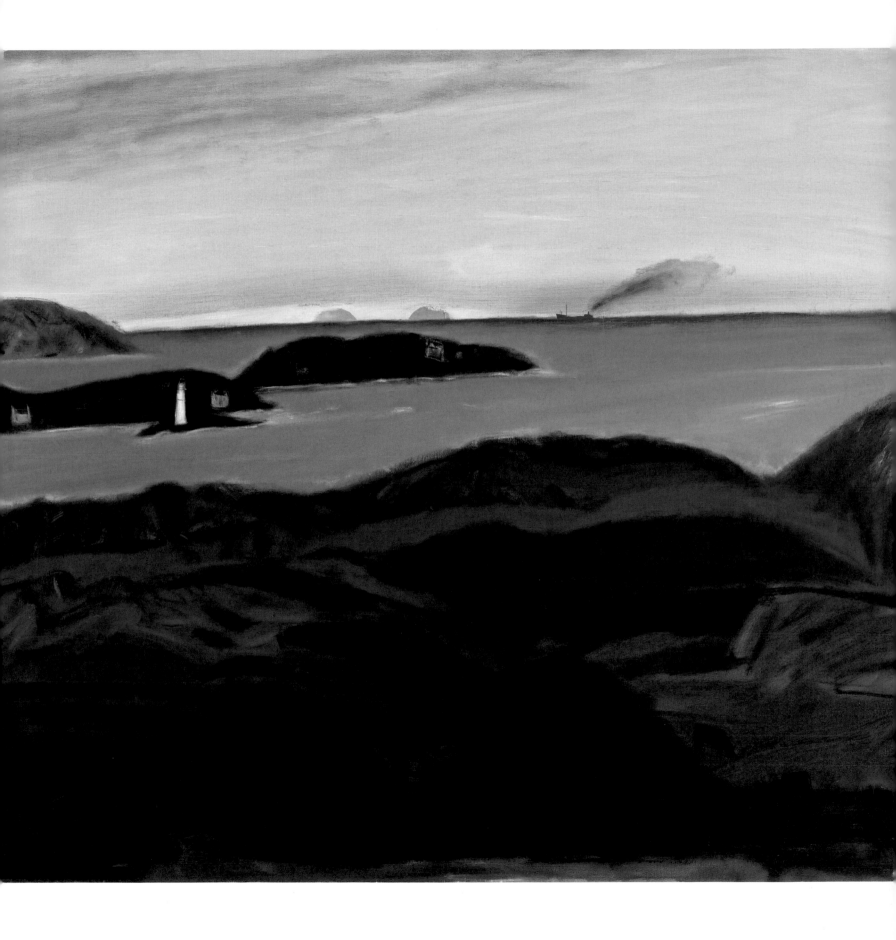

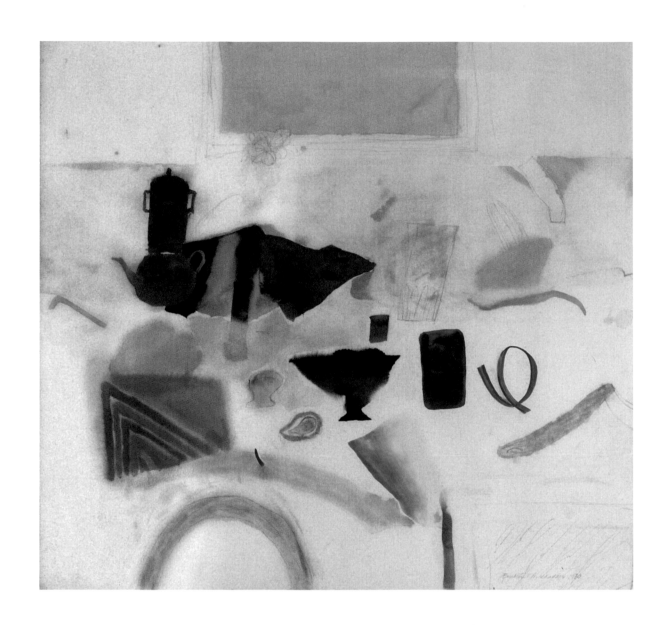

50 Still Life with Coffee Pot, 1970

Watercolour on paper, 63 × 67

Private collection

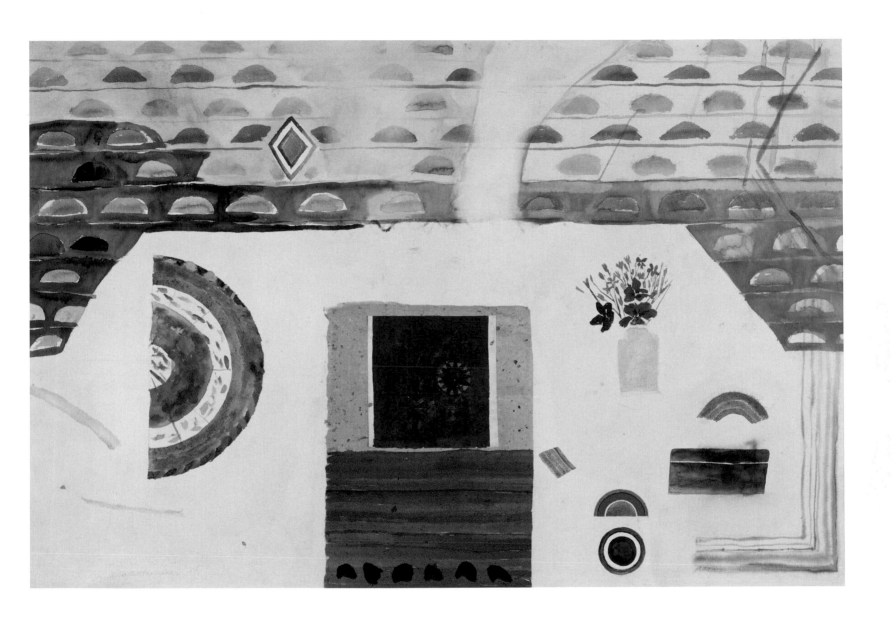

51 Still Life with Mexican Fan, 1970
Watercolour on paper, 69 × 100.5
Private collection

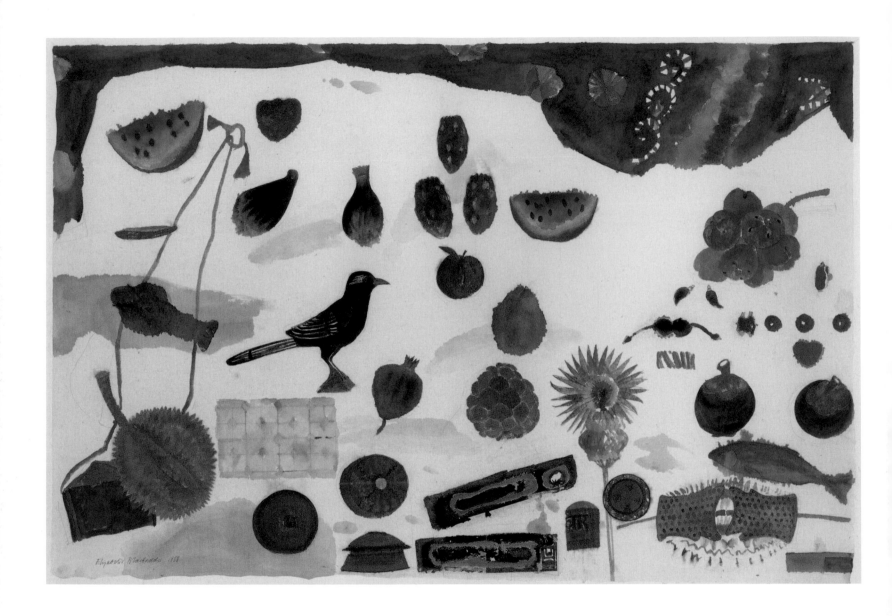

52 Exotic Fruit, 1988

Watercolour on paper, 62.9 × 92.7
Tom Rand and Ian Wilson

53 Still Life with Orchid, 1990

Oil on canvas, 101.5 × 112
Private collection

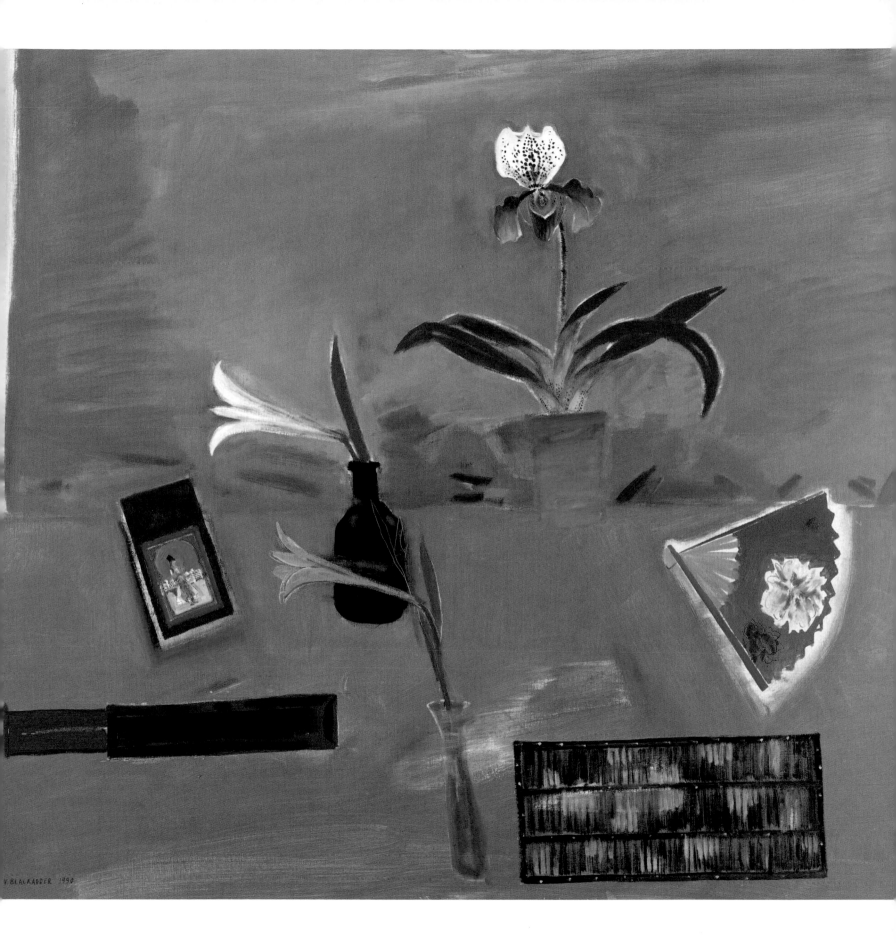

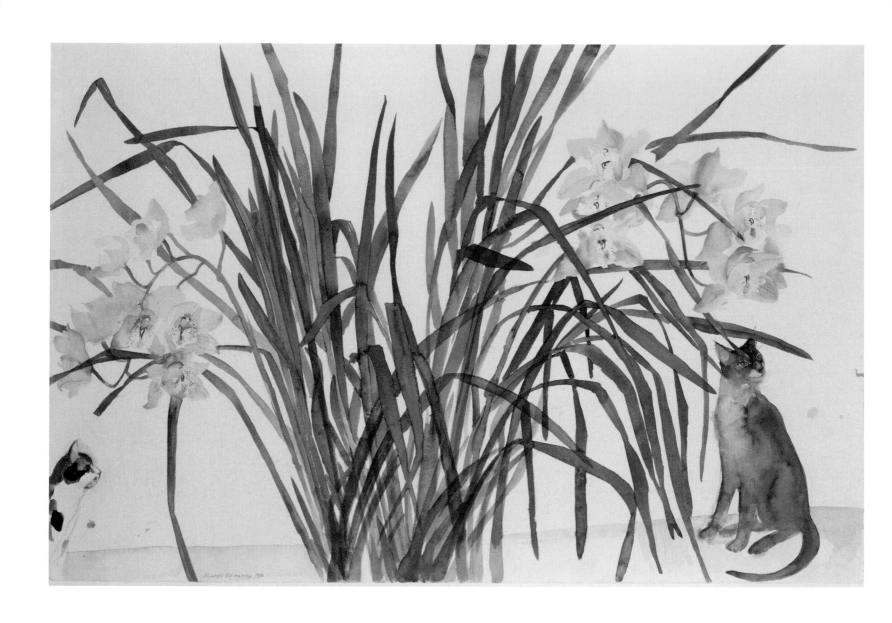

54 Cats and Orchids, 1984

Watercolour on paper, 80 × 120.8

Private collection

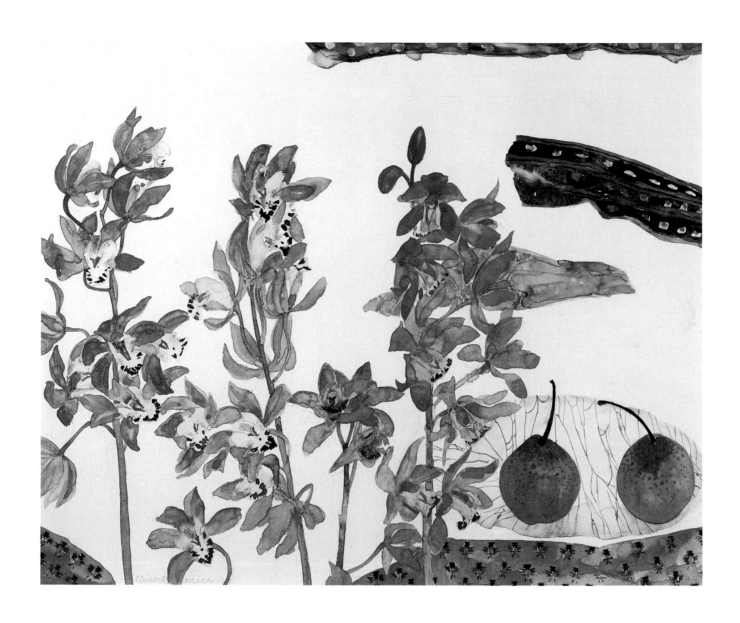

55 Orchids and Pears, 1985

Watercolour and pencil on paper, 42.5 × 53
Bequeathed by Miss Michelle Proud, 2002
Scottish National Gallery of Modern Art, Edinburgh

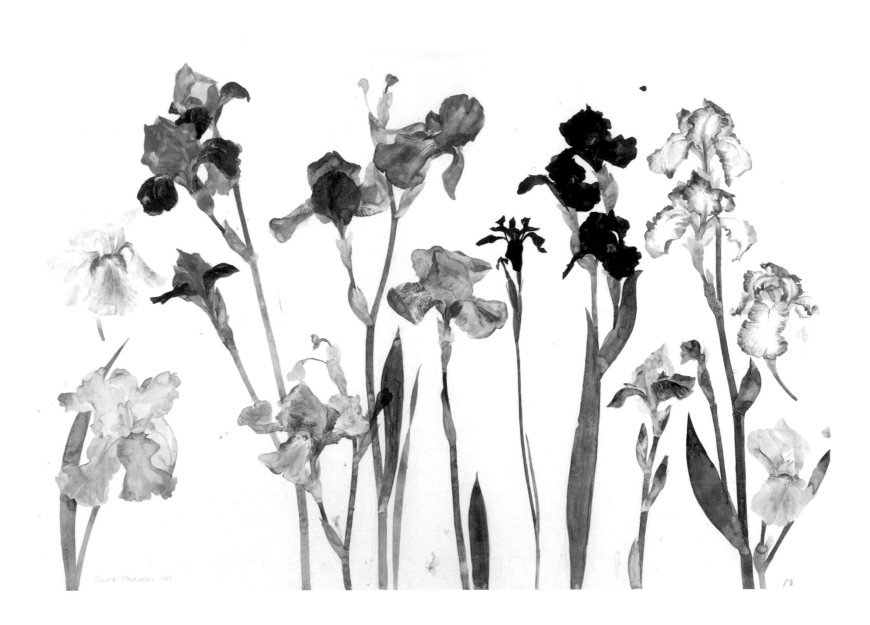

56 Irises, 1987

Watercolour on paper. 72 × 107

Private collection

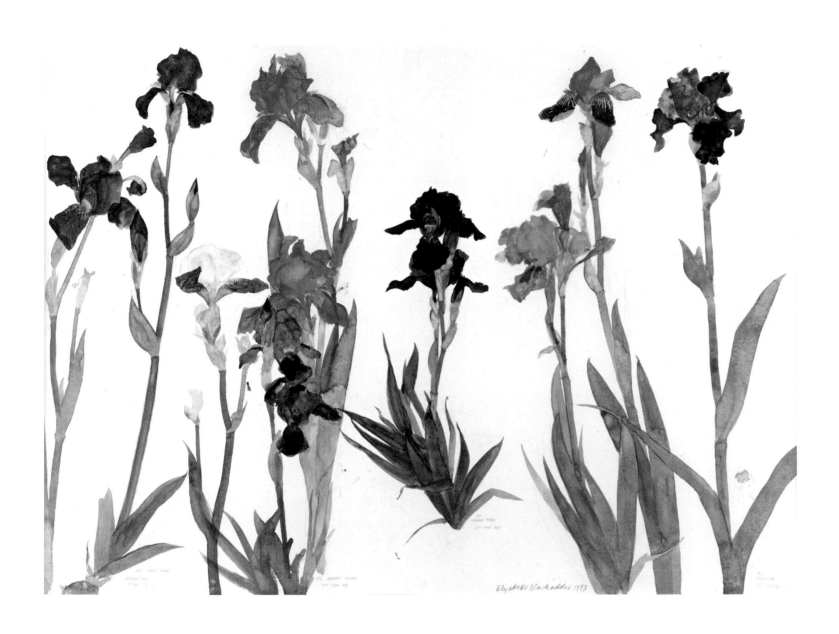

57 Irises, 1983

Watercolour on paper, 56.2 × 78.5

Private collection

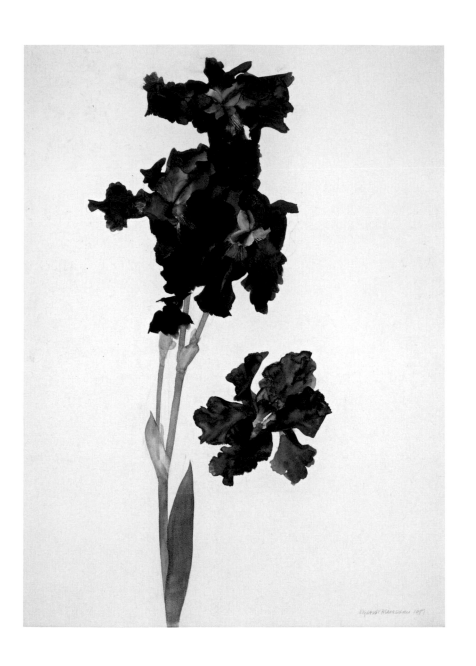

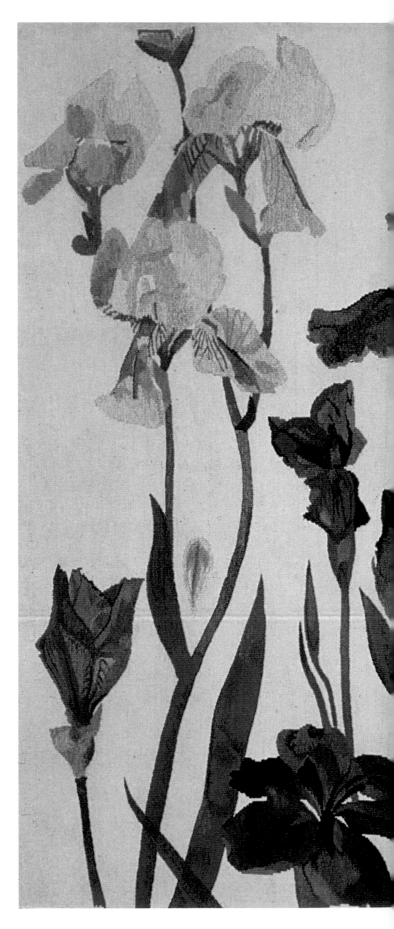

58 Irises, 1987

Watercolour on paper, 100 × 72
Private collection

59 Irises, 1987

Tapestry, 147 × 217
The Fleming-Wyfold Art Foundation

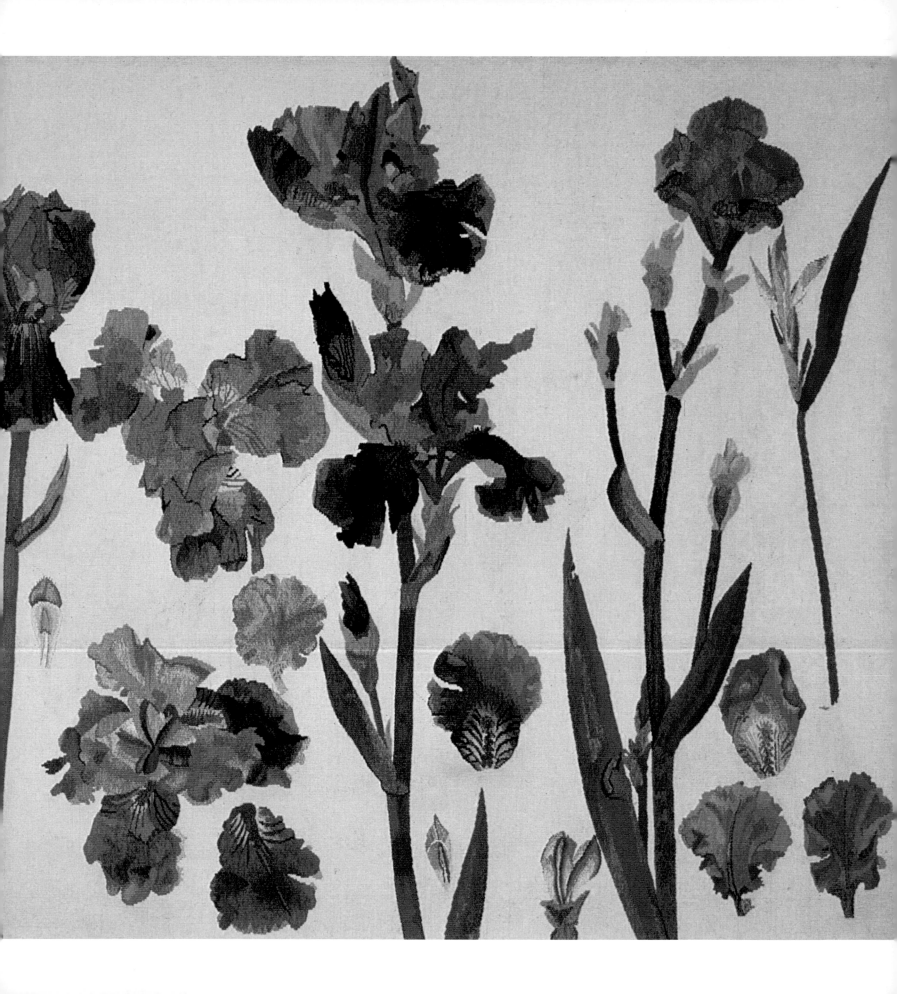

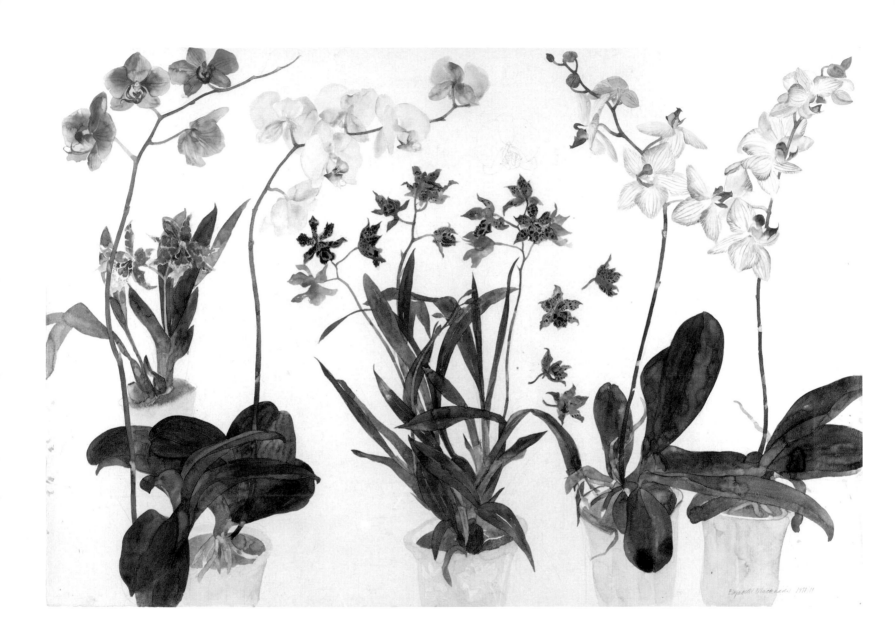

60 Orchids, 1988−9

Watercolour on paper, 72 × 107

Private collection

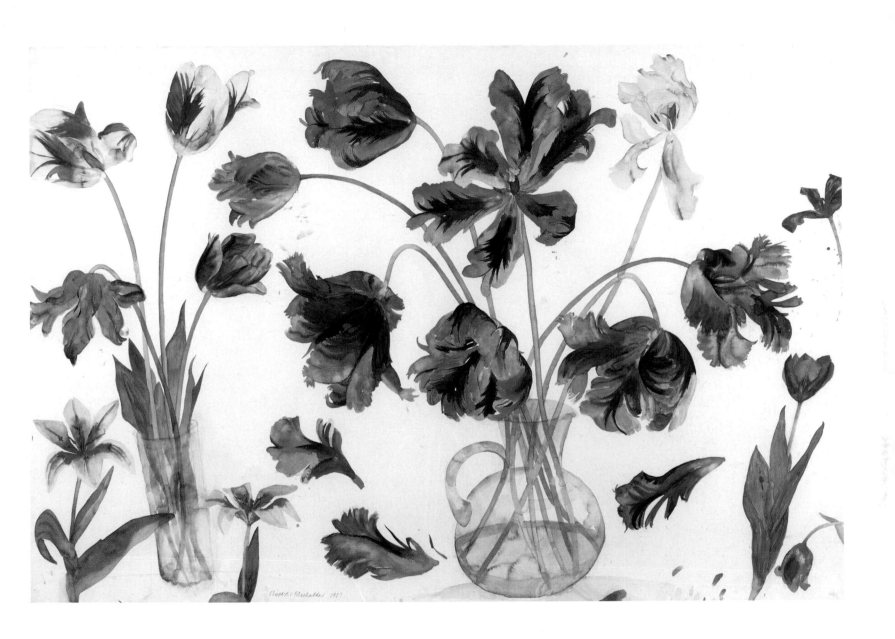

61 Tulips, 1987
Watercolour on paper, 72 × 107
Private collection

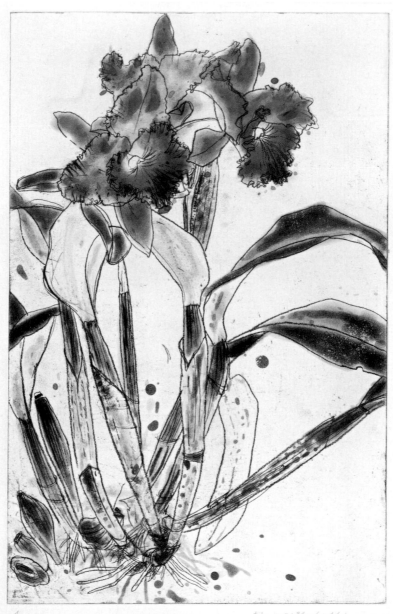

4/50 Elizabeth Blackadder

62 Orchid, 1985

Colour etching and aquatint on paper, 50.7 × 32.6
Scottish National Gallery of Modern Art, Edinburgh

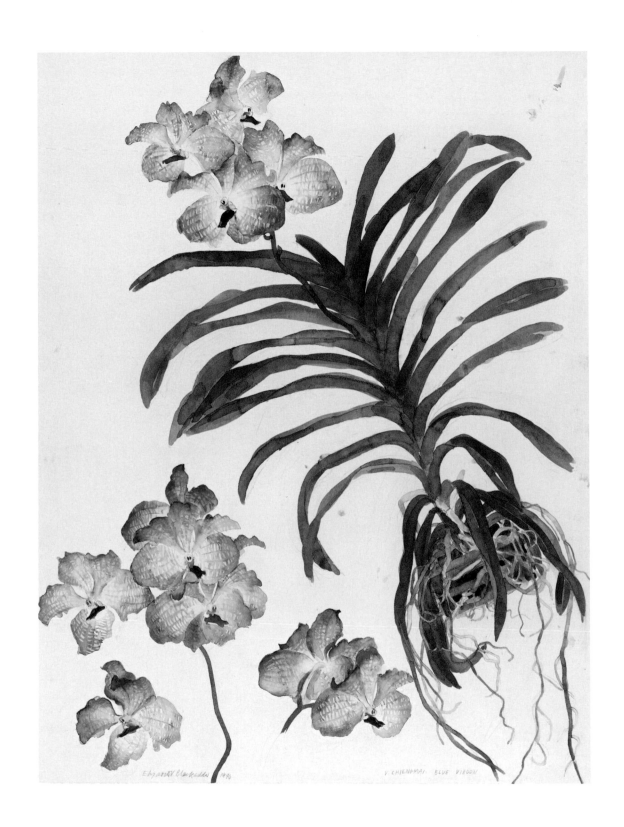

63 Orchid, Blue Vanda, 1994

Watercolour on paper, 79 × 56
Private collection

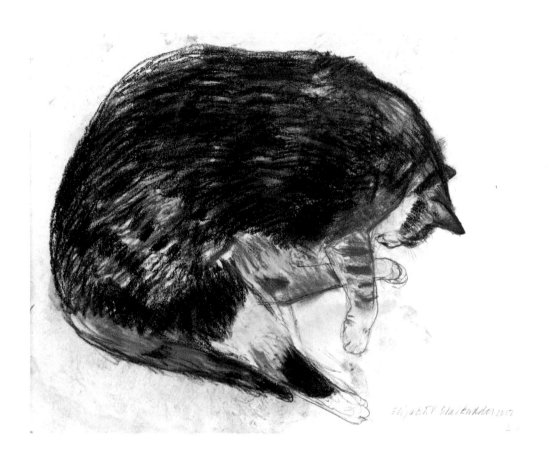

64 Kikko Asleep, 2002

Chalk on paper, 29 × 36
Private collection

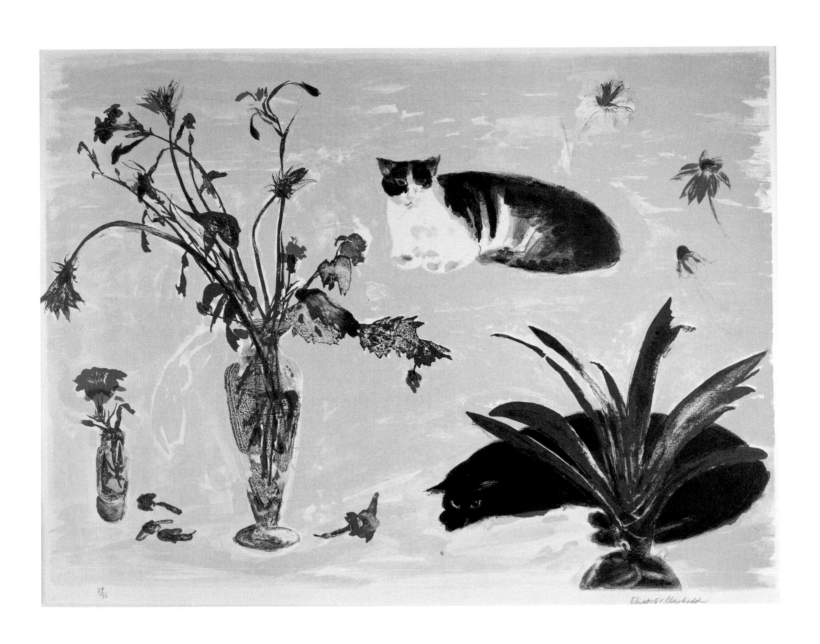

65 Cats and Flowers, 1979–80

Lithograph on paper, 62 × 83.7
Scottish National Gallery of Modern Art, Edinburgh

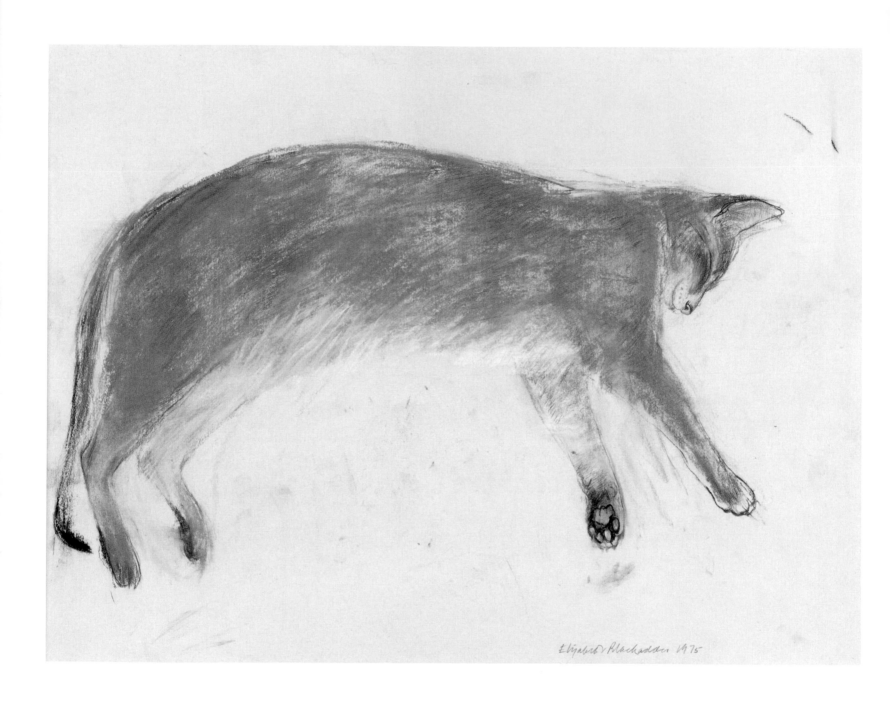

66 'Puskas' Sleeping (Abyssinian Cat), 1975

Chalk and pastel on paper, 38 × 51
Private collection

67 Studies of Cats, 1996

Pastel on paper, 94 × 76.2
Private collection

68 Two Cats, 1992

Etching and aquatint on paper, 41.5 × 58.7
Glasgow Print Studio

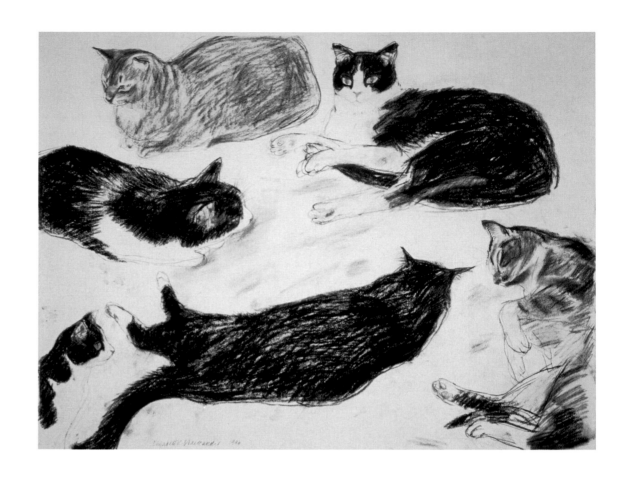

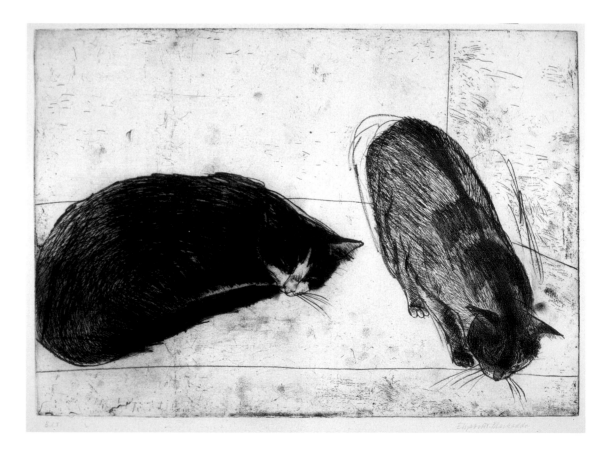

Elizabeth Blackadder

the inspiration of Japan

In 1981 Elizabeth Blackadder's work received its first retrospective, organised by the Scottish Arts Council. This premiered in Edinburgh and then toured across Britain, culminating in its exhibition at the Royal Academy in London, to which she had been elected in 1976. Throughout the 1970s Blackadder had exhibited her new work regularly in Edinburgh, London and elsewhere, and had been represented in numerous group exhibitions, but this was the first opportunity for audiences to see her art in totality. The exhibition tour ended in 1982, and in the same year she was awarded an OBE. In 1986 Elizabeth decided to retire from Edinburgh College of Art, bringing to an end a teaching career that had lasted some forty years and the beginning of a new phase in which she could concentrate completely on her own work.

Blackadder's interest in collecting objects from around the world and her fascination with the art of non-Western cultures had inspired and helped her to develop her own approach. She first became aware of the rich tradition of Japanese screen painting in Chicago in the late 1960s, and her tendency to stylise and abstract from objects and paint them within flat undefined space drew her naturally towards Oriental art. In 1979 she produced a watercolour, *Chinese Table, no.1* [71], which sets out Eastern objects in a manner familiar from the graphic syntax of Oriental art. Other cultures also made their mark on Blackadder's work – *Still Life with Peruvian Hat* of 1981 [70], for example, is

Elizabeth V. Blackadder 1998

enriched by the warm colour of South America, and the grid and ziggurat forms of the Aztec culture. In 1985, just prior to her retirement from teaching, an usually long three-week Easter break from college allowed Elizabeth and John to visit Japan, and they returned again the following year for a more extended visit, when their work was included (in the form of tapestries) in an exhibition from Edinburgh's Dovecot Studios, which was then being held in Tokyo. They travelled throughout the country, making a special point of visiting traditional gardens, and they returned to Japan again in 1992 and 1993, the results of which were shown in an outstanding exhibition of Blackadder's new work during the Edinburgh International Festival at The Scottish Gallery in 1994.

For Elizabeth the visual art of the Japanese Zen garden, with its concern for form and relationship between the constituent elements of rock, fields of gravel and planting, must have felt close to her own pictorial interests. The long format of scroll painting inspired new works on paper that were substantially wider than they were high, and required a different sort of interpretation that was more akin to reading. On a delicate scale but of extraordinary quality was the print Blackadder produced in collaboration with the Glasgow Print Studio (with whom she has worked regularly since the mid-1980s), entitled *Autumn, Kyoto* [95], issued in folding book form and featuring a series of exquisite vignettes based on Oriental motifs. The

architecture of Kyoto (formerly the Imperial capital of Japan) and the preciousness of its shrines provided special stimulus, and resulted in the largest watercolours the artist has made to date, such as *Shrine, Kyoto*, and *Large Shrine Kyoto* [76 & 77]. The elegance of these Buddhist buildings' grid forms and the transparent nature of Japanese screen architecture prompted Blackadder, unusually for her work in this medium, to fill the sheet with complex detail and introduce a sense of recession. Substantial oils resulted, such as *Interior, Kyoto, View of a Garden* [75], in which Blackadder contrasts the expansive sparse interior with the relative complexity of the garden seen through an opening framed by paper screens. In a further interior, the artist herself features, kneeling and dressed in a Japanese robe, gazing towards a brilliant red lacquer table top, a reflection perhaps on the long personal importance to her of the use of such a space in the development of her art [46]. Japanese subjects continue in the artist's work to this day, whether through the incorporation of Oriental objects into still lifes as in *Still Life with Japanese Print and Mirror* of 2005 [84], through paintings of exotically patterned kimonos acquired on travels, such as *Kimono* of 1999 (private collection), or through the remembrance of Japanese interiors seen on these earlier visits [85].

Detail from *Japanese Still Life – Black and Silver*, 1998 [78]

81

69 Still Life with Indian Toy, 1984

Tapestry, 170 × 188

Aberdeen Art Gallery & Museums Collections

70 Still Life with Peruvian Hat, 1981

Watercolour on paper, 63.5 × 94
Private collection

71 Chinese Table, no. 1, 1979

Watercolour on paper, 70 × 100
Perth Museum and Art Gallery

72 Still Life with Japanese Sweets, 1998

Watercolour and paper, 70 × 110

Private collection

73 Shrine, Fushimi, 1999

Oil on canvas, 91.5 × 96
Private collection

74 Temple Façade, Nara, 1994

Oil on canvas, 101.5 × 127
Private collection

75 Interior, Kyoto,
View of a Garden, 1991

Oil on canvas, 122 × 122
Private collection

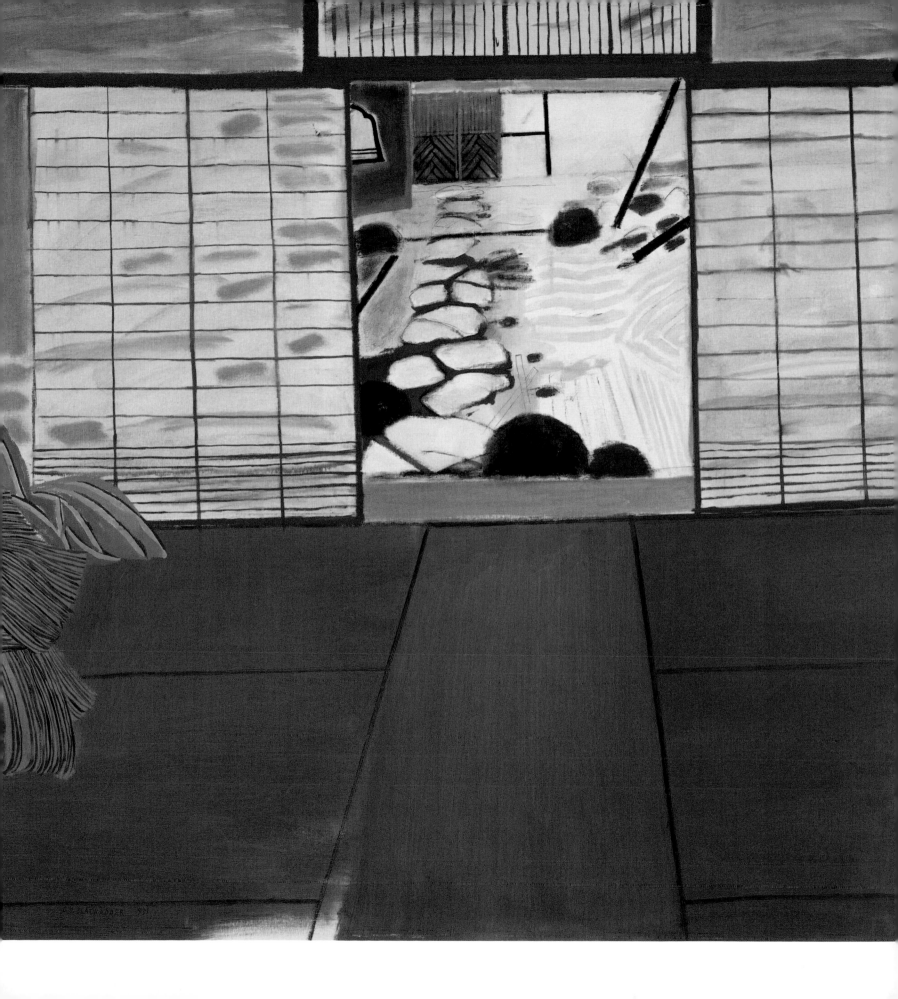

76 Shrine, Kyoto, 1993

Watercolour on paper, 75 × 116
Private collection

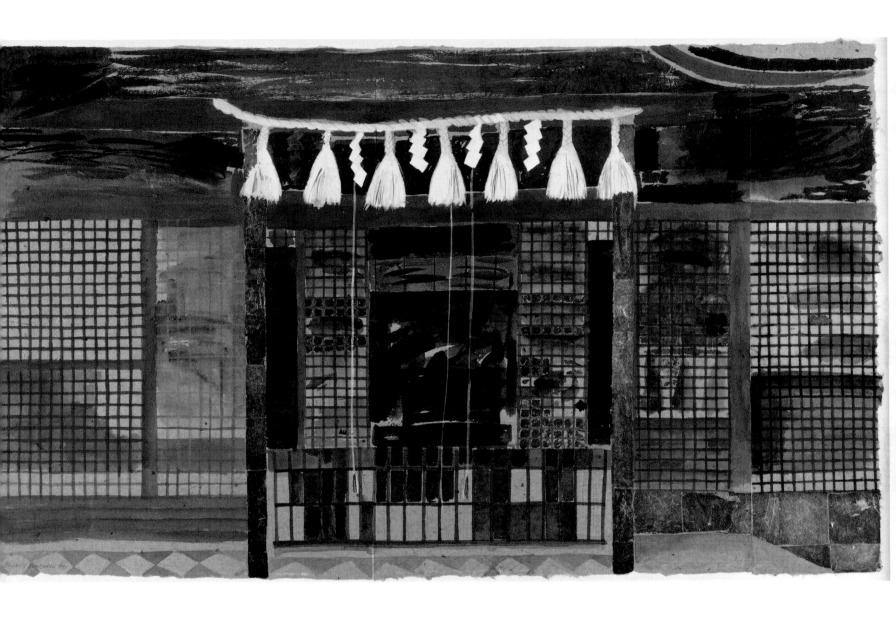

77 Large Shrine, Kyoto, 1994
Watercolour on paper, 81 × 137
Private collection

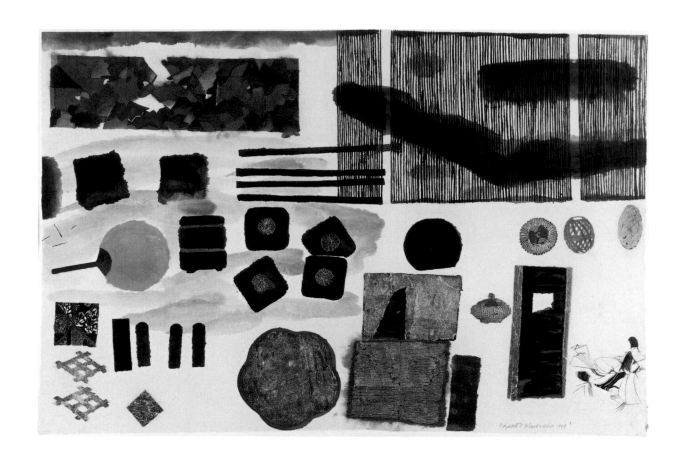

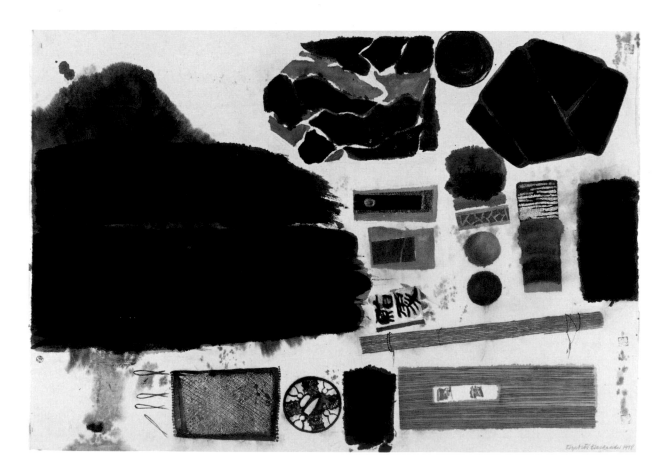

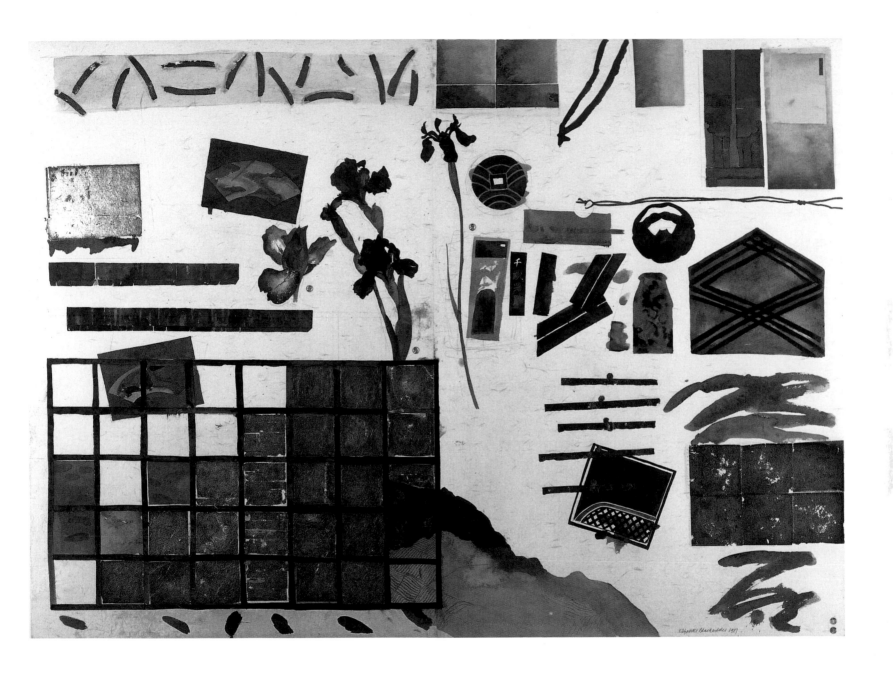

78 Japanese Still Life – Black and Silver, 1998

Watercolour and gold leaf on paper, 71 × 105
Private collection

79 Japanese Still Life with Sword Guard, 1998

Watercolour and gold leaf on paper, 61 × 86.5
Private collection

80 Still Life, Nikko, 1987

Watercolour and gold leaf on paper, 80 × 120
Private collection

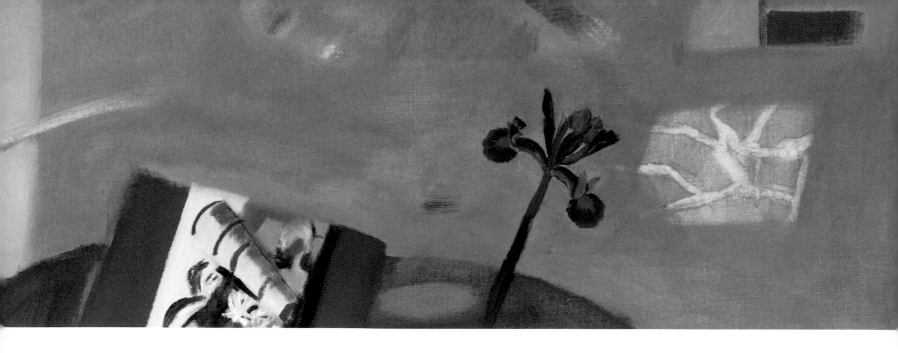

Elizabeth Blackadder
recent work

A reading of Elizabeth Blackadder's recent chronology makes clear the high regard in which she is held. The artist has been honoured extensively, with the particular distinction of her appointment in 2001 as Her Majesty's Painter and Limner in Scotland, a unique Scottish position within the Royal Household that has origins in the late sixteenth century, and which was first conferred on a distinguished artist, Henry Raeburn, in 1823. In service to Her Majesty, in 2010, Blackadder completed a portrait drawing of Lord May of Oxford, the eminent zoologist. This commission is the most recent in a series of portraits the artist has undertaken, which includes the author Naomi Mitchison of 1988; the Scottish textile historian Margaret Swain of 1999 and the former Edinburgh Lord Provost Eric Milligan in 2006.

While Blackadder is quietly proud of the honours she has received, the ongoing commitment she makes to her work suggests that such public attention must be a distraction to the daily routine she enjoys as a practising artist. Following her husband John's retirement from Edinburgh College of Art in 1989 shortly after her own, the two artists fell into a daily routine, dealing with administrative matters during the first part of the day, and then from early afternoon working in their respective studios. Drawing and painting would continue long into the evening, a habit difficult to break following many years of teaching commitments throughout the day.

In 1985 John and Elizabeth were invited by John

Detail from *Still Life with Iris*, 2000 [87]

Mackechnie of Glasgow Print Studio to make etchings there, beginning a relationship with the workshop and gallery which for Elizabeth continues today. While Blackadder has purposefully restricted her subject matter to what she observes, since early in her career her methods of approach have been multiple. She has experimented with technique, compositional methods and combinations of motifs, depending on subject, circumstances and suitability. Away from the solitary practice of painting and drawing, Blackadder has enjoyed the exposure to new methods she has learnt through printmaking. Etching and aquatint in particular has been favoured, combining a linear technique with one producing an even tone, used to great effect in studies such as *Orchid* of 1985 [62]. The more recent invention of carborundum printing was chosen to make *Dogana, Venice* of 1999–2000 [91]. This method of printing gives an embossed appearance which is particularly suited to the expression of the mottled and weighty golden globe that surmounts this historical Venetian building. Perhaps because of the physicality demanded by woodcut Blackadder has used this technique only once, to make the ambitious *Strelitzia* of 1989 (private collection), surely her boldest graphic image.

Dramatic shifts within conveniently short timescales cannot be identified in Blackadder's art. Rather, her approach has been steadfast, combining disciplined working with an intuitive, unpremeditated approach as to how a composition might develop. The artist's long experience has allowed the execution of large canvases such as *Still Life with Iris* of 2000 [87], a painting remarkable in scale given its execution in the artist's seventieth year. In reproduction its different elements may appear disconnected, but face-to-face with the work the overwhelming effect is of a unified tapestry of rich colour and form.

A particular interest in colour might indeed be said to distinguish Blackadder's work of the last decade. In oils such as *Still Life with Gerberas, Moonlight* of 2004 [81], flower heads and broad leaves are depicted with a sharpness, both in their form and acid colour, which demands attention. *Melon, Aubergine and Chinese Cloth* [86] of the same year by comparison uses colour in a richer, more sonorous manner. Both canvases share a sense that the artist is striving to find the right method and mood for the most honest depiction of her motifs. We may also observe that in many of the artist's most recent oils there is less attention given to overall flat pattern, but instead a greater use of spatial depth as a setting for clearly identifiable objects.

If a shift of interest in the expressive use of colour and manipulation of space is evident in the artist's most recent oil painting, then a further characteristic of the last decade is a more intense analysis of the natural world. Blackadder has admitted her principal fascination is with nature's extraordinary invention.[1] Although she now travels less,

81 Still Life with Gerberas, Moonlight, 2004

Oil on canvas, 100 × 112
Private collection

82 Fred and Chest of Drawers, 1998

Oil on canvas, 100 × 80
Private collection

friends who appreciate her interests regularly present
her with objects or material they have collected at home
and abroad. In this way, through a friend's gift, the softly
coloured, beautifully etched *Seed Pod and Bees* of 2004
[92] came about. Perhaps one of the artist's most striking
works of the last few years is *Orchids, Zygopetalium,
Dendrobium and Odontoglossum*, also of 2004 [88],
featuring a rich variety of plant forms that the artist
has drawn in dark strokes of pencil, and in parts used
coloured pencil to show distinct flower heads. The
abruptness of these colour additions and the stark nature
of line differentiate this drawing from the comparative
showmanship of the large watercolour flower paintings
of the 1980s, and (for this author) the sheer investiga-
tory force of this recent work takes it beyond these
earlier paintings. As Elizabeth Blackadder approaches
her eightieth birthday her thirst for the world and her
means of understanding has resulted in an outstanding
body of work that continues to probe and investigate.
Blackadder's compulsive fascination with what is around
her enables the artist to continue to bring the same
energy to her work as she did at the outset of what has
now become a long and pre-eminent career.

1 The artist in conversation with the author, May 2011

94

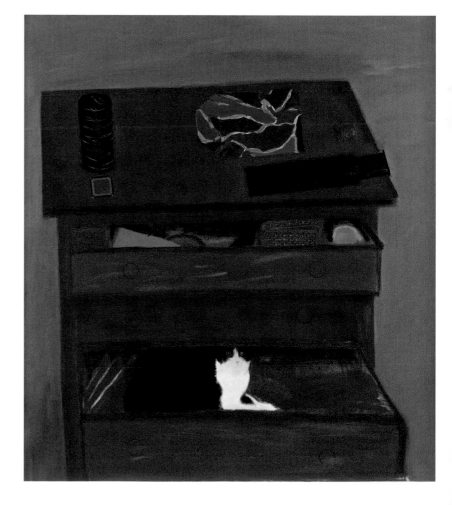

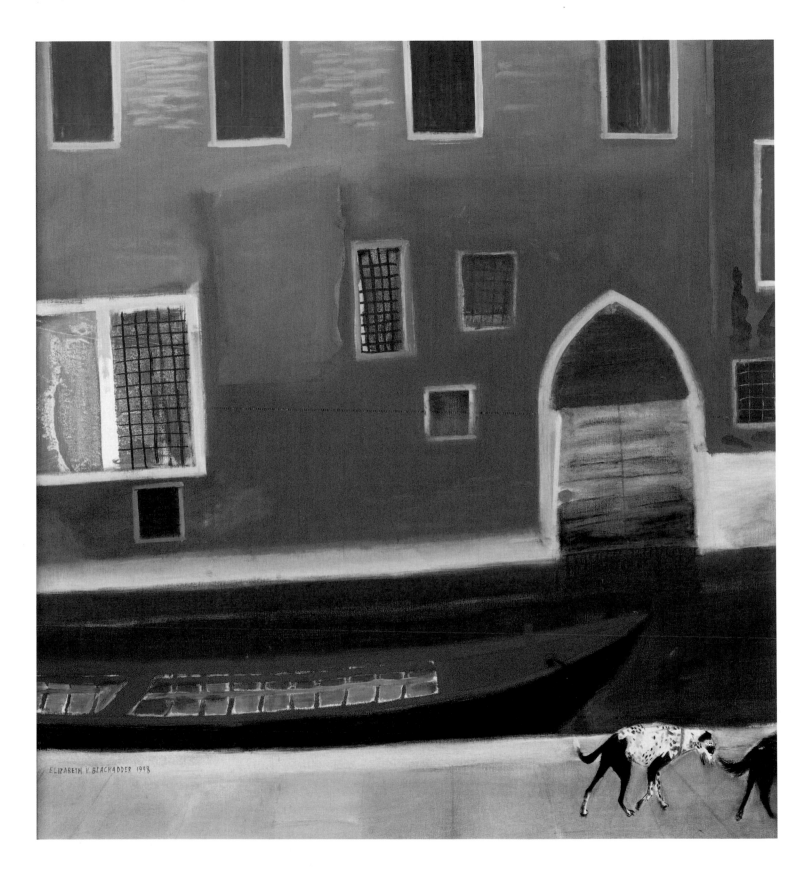

83 Venetian Canal with Dogs, 1998

Oil on canvas, 80 × 60

Private collection

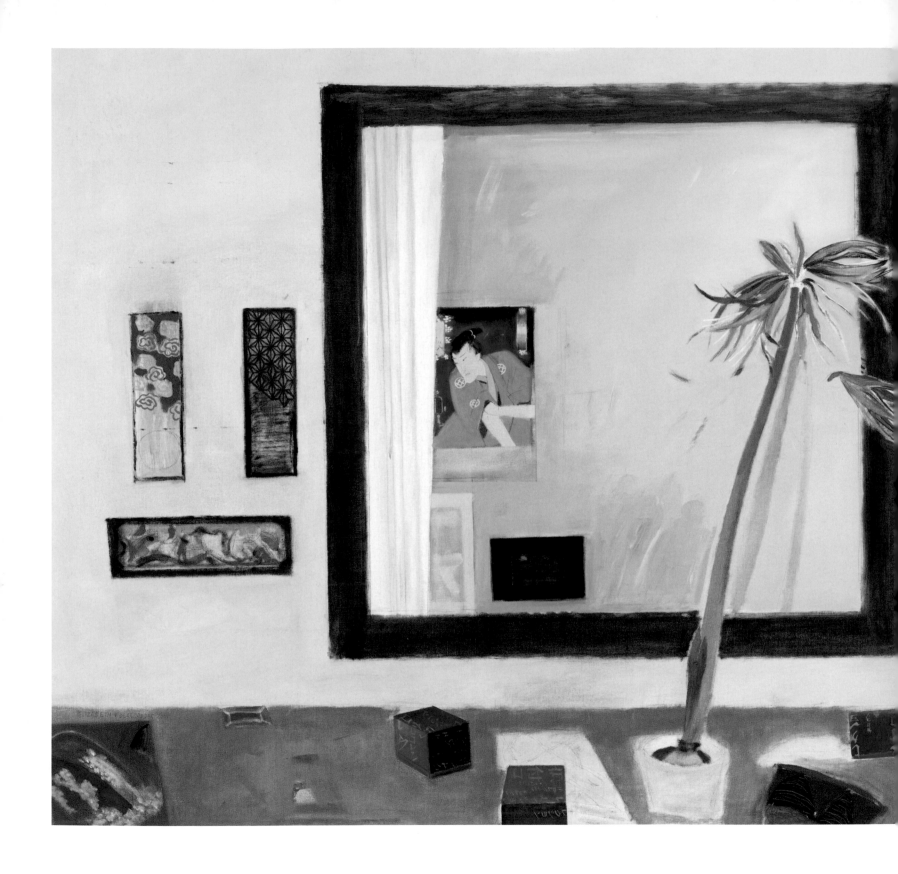

84 Still Life with Japanese Print and Mirror, 2005

Oil on canvas, 110 × 122
Private collection

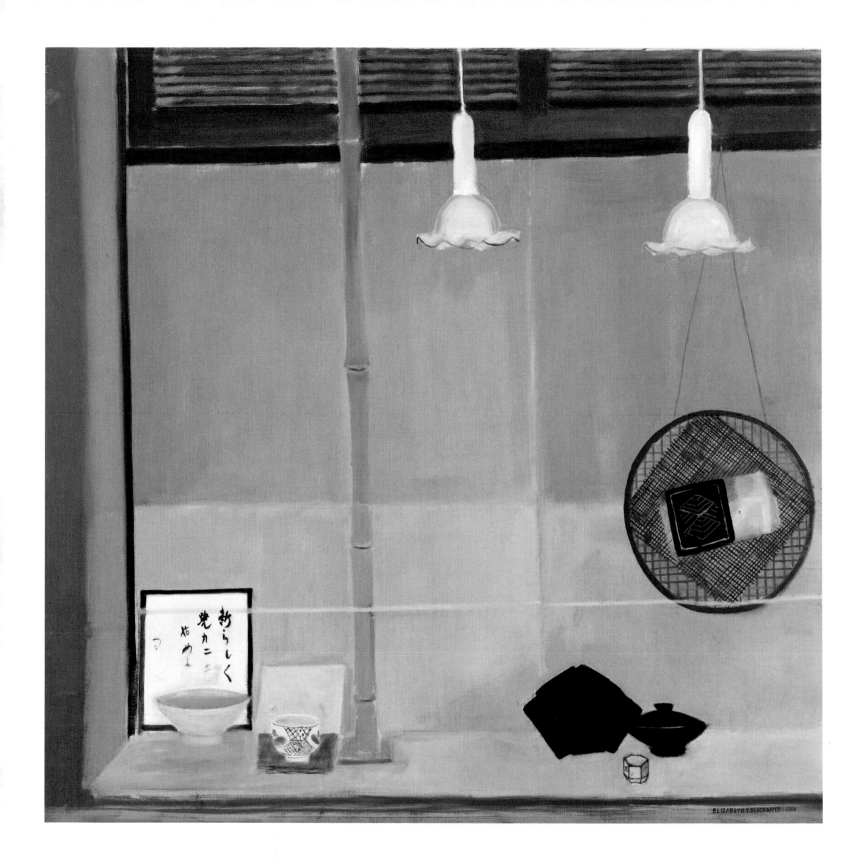

85 Japanese Interior, 2006

Oil on canvas, 122 × 122
Private collection

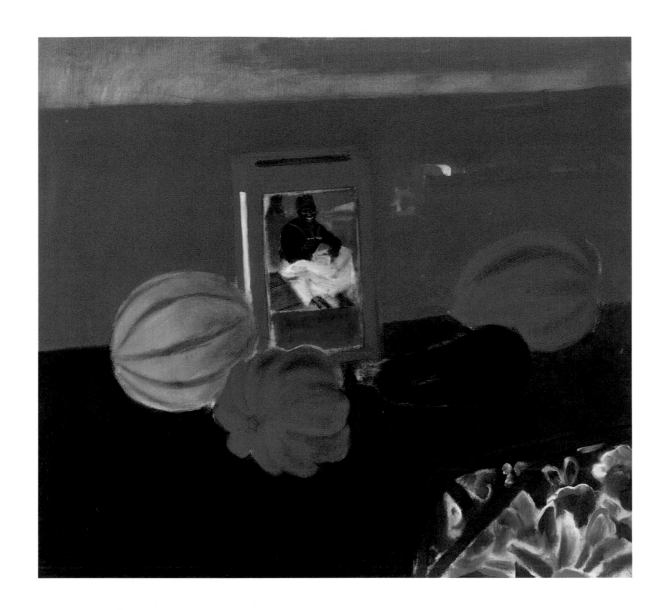

86 Melon, Aubergine and Chinese Cloth, 2004

Oil on canvas, 44 × 62
Private collection

87 Still Life with Iris, 2000

Oil on canvas, 183 × 183
Private collection

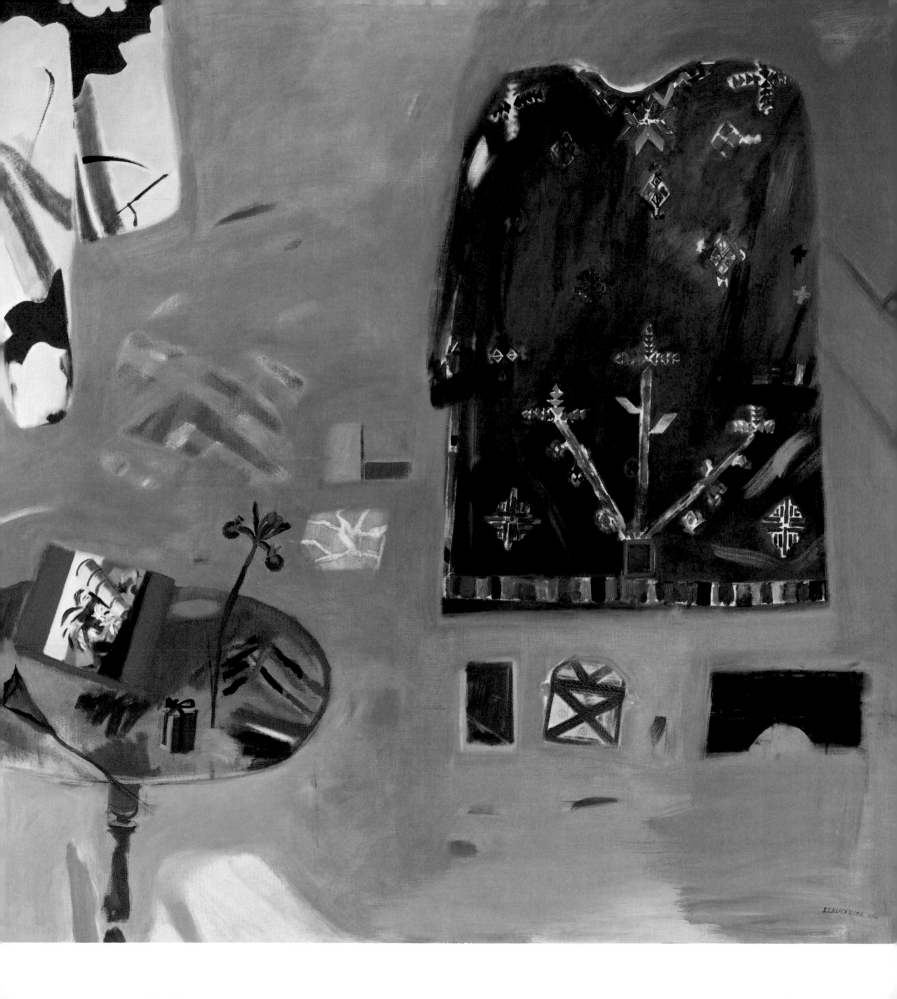

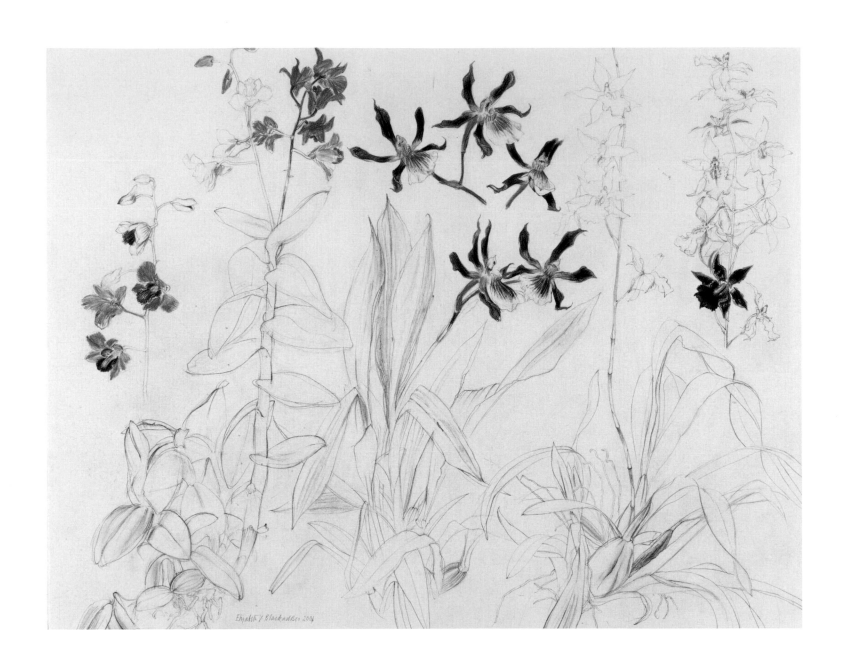

88 Orchids, Zygopetalium, Dendrobium and Odontoglossum, 2004

Pencil and coloured pencil on paper, 64 × 82

Private collection

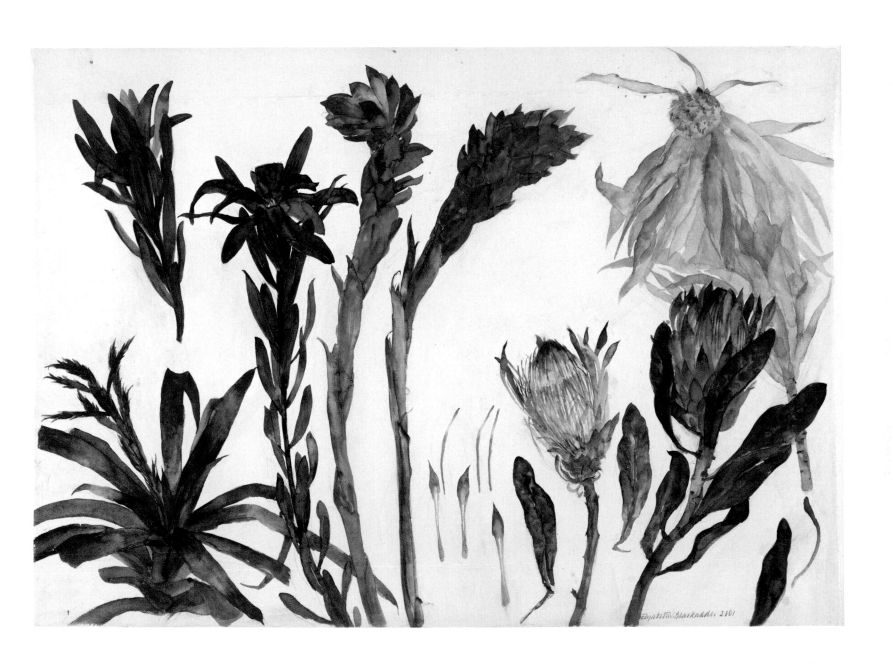

89 Proteus, Leucadendrons and Other Plants, 2001

Watercolour on paper, 57 × 80
Private collection

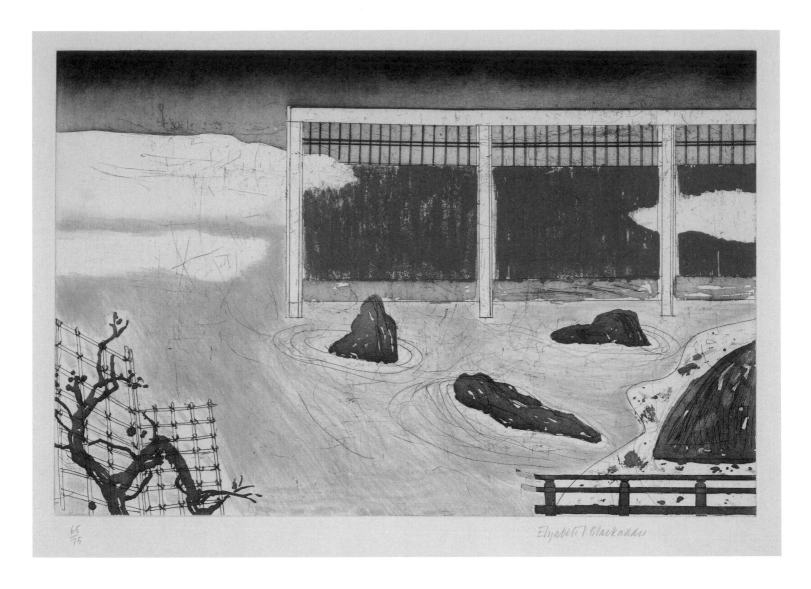

65/75 Elizabeth V. Blackadder

1/10 The Dogana, Venice Elizabeth V. Blackadder

90 Japanese Garden, Dublin, 2004

Etching on paper, 36.5 × 54.5
Glasgow Print Studio

91 Dogana, Venice, 1999–2000

Carborundum on paper, 18.2 × 28.5
Private collection

92 Seed Pod and Bees, 2004

Etching on paper, 22.9 × 26.7
Glasgow Print Studio

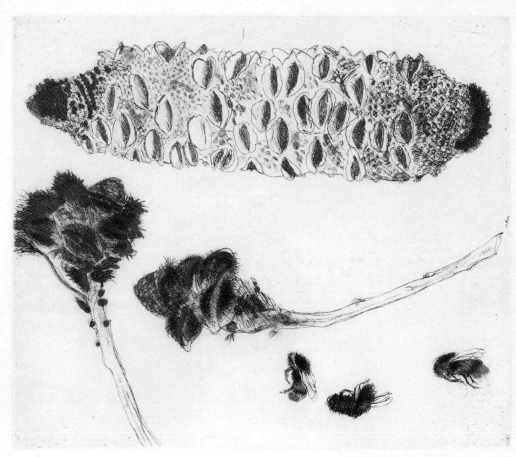

Elizabeth Blackadder

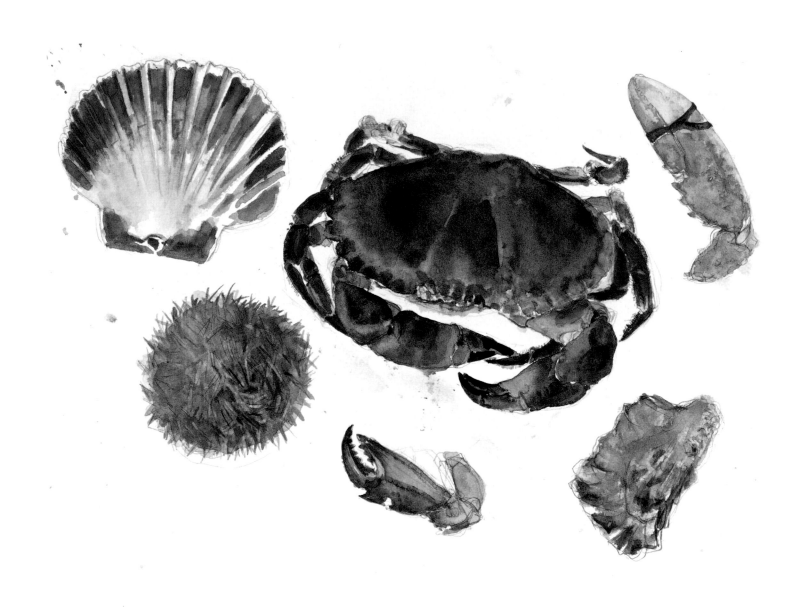

93 Crab and Shells, 2011

Watercolour and pencil on paper, 31 × 47
Private collection

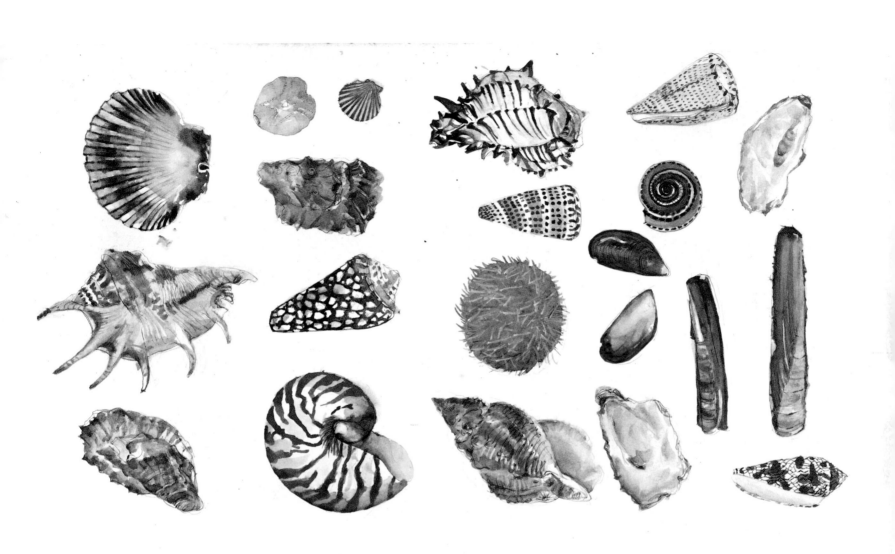

94 Shells, 2011
Watercolour and pencil on paper, 41 × 70
Private collection

Elizabeth Blackadder painting
in her garden, Edinburgh, 1981
Photo: Antonia Reeve

Elizabeth Blackadder
chronology

1931

Born 24 September 1931 in Falkirk, Scotland, to Thomas Blackadder, engineer, and Violet Isabella Blackadder, teacher.

Early education at Falkirk Primary School.

1941–3

Death of father, Thomas Blackadder.

Stays with maternal grandmother in Kilmun, Argyll, where she lives with three great aunts, near the shores of the Holy Loch. Attends primary school in nearby Strone.

Later attends Dunoon Grammar School.

1943–9

Returns to Falkirk to complete secondary education at Falkirk High School.

Interest in flowers, music and literature; school subjects include Art and Higher Botany.

Holidays spent at Kilmun, North Berwick and St Andrews.

1949–54

Studies at Edinburgh College of Art and University of Edinburgh for a masters degree in Fine Art under William Gilles, Head of the School of Drawing and Painting, and Professor David Talbot Rice, Professor of Fine Art.

Teachers include Penelope Beaton, Robert Henderson Blyth, Robin Philipson, William MacTaggart and Leonard Rosoman. Fellow students included David Michie, John Busby, David McClure, Hamish Reid, Frances Walker and future husband John Houston.

1954–5

Awarded the Carnegie Travelling Scholarship by the Royal Scottish Academy and upon graduating travels in the summer of 1954 to Italy, Greece and Yugoslavia with John Houston. Returns to Edinburgh College of Art to undertake postgraduate study for the session 1954–5.

1955–6

Awarded the Andrew Grant Travelling Scholarship by Edinburgh College of Art. Spends nine months in Italy, based in Florence from September 1955.

Exhibited work from this period at Edinburgh College of Art on her return in 1956.

1956

Selected for *8 Young Contemporaries*, Gimpel Fils Gallery, London.

Marries John Houston.

Moves to a flat at 7 London Street in Edinburgh's New Town, living above Anne Redpath.

Appointed to a two-year part-time lecturing post at Edinburgh College of Art.

Elected member of the Scottish Society of Artists.

1958

Selected by the Scottish Committee of the Arts Council of Great Britain to produce lithographs with the Harley Brothers, St James's Square, Edinburgh.

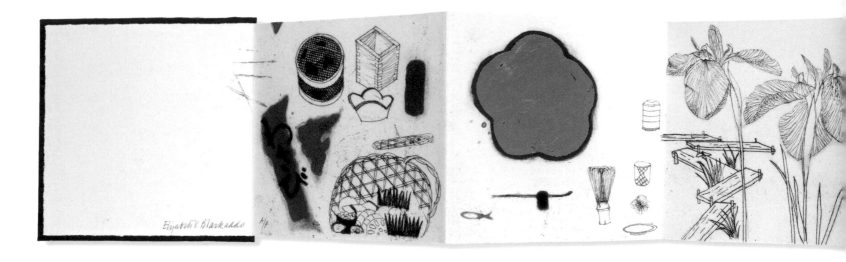

1957

Travels to Spain: Barcelona and Madrid.

1958–9

Teacher training course at Moray House, Edinburgh, with a teaching post at St Thomas of Aquin's School, Edinburgh.

1959

First solo exhibition: 57 Gallery, George Street, Edinburgh.

1959–62

Librarian at the Fine Art Department, University of Edinburgh.

1960

Travels to France: Normandy and Brittany.

Exhibits for the first time at The Scottish Gallery, Edinburgh.

1961

Elected member of the Royal Scottish Society of Painters in Watercolour.

Included in the exhibition *Contemporary Scottish Painting*, Toronto, Canada.

1962

Appointed full-time lecturer at Edinburgh College of Art (teaching there until 1986).

Awarded the Guthrie Award by the Royal Scottish Academy for *White Still Life, Easter*.

Commissioned by the General Post Office to produce a lithographic poster, *Staithes, Yorkshire*.

Travels through Greece, visiting pre-Hellenistic sites and Byzantine churches. Goes to Istanbul to see mosaics.

1963

Elected Associate of the Royal Scottish Academy.

Moves to Queen's Crescent, Edinburgh.

Included in the exhibition *20th Century Scottish Painting*, Abbot Hall Art Gallery, Kendal.

Travels in France through the Loire Valley.

1963–4

Included in the exhibition *14 Scottish Painters*, Scottish Committee of the Arts Council of Great Britain exhibition at the Commonwealth Institute, London and Kelvingrove Art Gallery, Glasgow.

Visits the south of France.

1965

First solo exhibition at the Mercury Gallery, London.

Returns to the south of France.

1966

Solo exhibitions at The Scottish Gallery and Thames Gallery, Eton.

Visits Portugal.

1967

Commissioned by Mrs John Noble to design a tapestry for the Scottish National Gallery of Modern Art, woven at the Edinburgh Tapestry Company.

Solo exhibition at the Mercury Gallery, London.

Visits Spain and Portugal.

1968

Solo exhibitions at Reading Art Gallery and Museum and Lane Art Gallery, Bradford.

Included in *Three Centuries of Scottish Painting*, National Gallery of Canada, Ottawa.

Visits Holland and Germany.

1969

Solo exhibition at the Mercury Gallery, London.

First visit to the United States, accompanying John Houston, who had been commissioned to paint around Lake Michigan, Wisconsin.

1970

Solo exhibition of watercolours, Vaccarino Gallery, Florence.

1971

Elected Associate of the Royal Academy of Arts, London.

Solo exhibitions at Mercury Gallery, London and Loomshop Gallery, Fife.

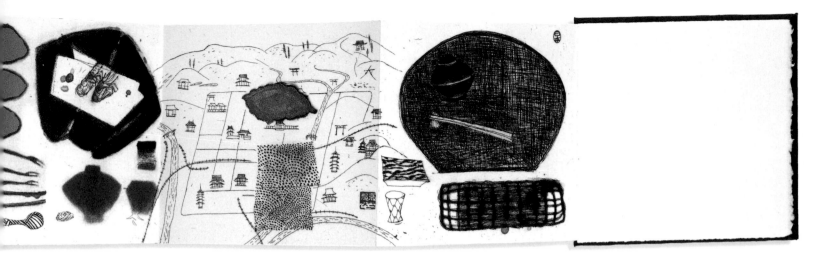

Included in *The Edinburgh School 1949–71*, Edinburgh College of Art.

First visit to Switzerland (painting at Lake Thun).

1972

Elected Academician of the Royal Scottish Academy, Edinburgh.

Solo exhibition at The Scottish Gallery, Edinburgh.

Visits Switzerland, Austria and southern Germany.

1973

Solo exhibition at the Mercury Gallery, London.

Paints in Switzerland (Schwyz and Lake Lucerne).

1974

Solo exhibitions at The Scottish Gallery (Edinburgh Festival Exhibition) and Loomshop Gallery, Fife.

First visit to the Isle of Harris in the Western Isles.

1975

Moves to Fountainhall Road, Edinburgh.

Included in *Edinburgh Ten 30*, Scottish Arts Council exhibition at the Royal Cambrian Academy of Art, Conway, and touring within Wales.

1976

Elected Academician of the Royal Academy of Arts, London.

Solo exhibitions at Mercury Gallery, London and Loomshop Gallery, Fife.

Included in the Royal Scottish Academy's 150th anniversary exhibition, *The Royal Scottish Academy 1826–1976*.

Travels in Italy.

1977

Solo exhibitions at Middlesbrough Art Gallery and Museum; Stirling Smith Museum and Art Gallery, and Hambledon Gallery, Blandford, Dorset.

Included in *British Painting, 1952–77*, the Royal Academy of Arts, London.

Visits Vienna.

1978

Solo exhibitions at the Mercury Gallery, London and Yehudi Menuhin School, Stoke d'Abernon, Surrey.

Included in *Painters in Parallel*, Scottish Arts Council exhibition at Edinburgh College of Art (Edinburgh Festival Exhibition).

Begins a series of paintings and sketchbooks using flowers from the garden at Fountainhall Road as source material.

Visits northern France. Works on a series of watercolours and drawings of the Normandy and Brittany coastline.

95 Autumn Kyoto, 1996
Etching and aquatint on paper, 18 × 152
Private collection

1979

Commissioned by the Mercury Gallery, London, to produce two lithographs: *Still Life with Indian Toy* and *Black Cat*.

Works on the northern coast of France, at Perros-Guirec, Loguivy, Trouville, Honfleur and Dieppe.

1980

Commissioned by the Edinburgh Tapestry Company to design a tapestry, *Eastern Still Life*.

Solo exhibitions at the Mercury Gallery, London, and Oban Art Society.

Included in the group exhibitions:

The British Art Show, Arts Council of Great Britain touring exhibition to Sheffield, Bristol and Newcastle.

Master Weavers – Tapestry from the Dovecot Studios 1912–1980, Scottish Arts Council (Edinburgh Festival Exhibition).

Paints in Normandy and Brittany.

1981–2

First retrospective exhibition: *Elizabeth Blackadder*, organised by the Scottish Arts Council and held at the Fruitmarket Gallery, Edinburgh and touring to Graves Art Gallery, Sheffield; Aberdeen Art Gallery; Bluecoat Gallery, Liverpool; Turner House, National Museum of Wales, Cardiff, and Royal Academy of Arts, London.

1982

Awarded OBE.

Solo exhibitions at Theo Waddington Gallery, Toronto, Canada; Bohun Gallery, Henley-on-Thames; Mercury Gallery, London and Edinburgh.

Included in *Six Scottish Painters*, Graham Gallery, New York.

1983

Solo exhibition at the Lillian Heidenberg Gallery, New York.

1984

Elected member of the Royal Glasgow Institute of the Fine Arts.

Commissioned by Reckitt and Colman for a tapestry, woven at the Edinburgh Tapestry Company.

Solo exhibition at the Mercury Gallery, London.

Visits Berlin.

1985

Elected honorary member of the Royal West of England Academy.

Begins printmaking at Glasgow Print Studio.

Solo exhibition at the Mercury Gallery, Edinburgh (Edinburgh Festival Exhibition).

First visit to Japan.

1986

Retires from teaching at Edinburgh College of Art.

Elected Honorary Fellow of the Royal Incorporation of Architects in Scotland.

Solo exhibition at the Lillian Heidenberg Gallery, New York.

Included in the Edinburgh Tapestry Company exhibition *Dovecot Studios' Tapestries*, Tokyo, touring to Australia (1989) and Houston, Texas (1990).

Second visit to Japan and to Hong Kong.

1987

Commissioned by the Scottish National Portrait Gallery to paint the portrait of the writer Mollie Hunter.

Portrait of Lady Naomi Mitchison purchased by the National Portrait Gallery, London.

Solo exhibitions at Mercury Gallery, London; Henley-on-Thames Festival of Music and Arts; and jointly with John Houston, at Glasgow Print Studio.

Included in exhibition *Art into Botany*, Talbot Rice Gallery, Edinburgh.

1988

First monograph on Blackadder's work, by Judith Bumpus, published by Phaidon Press.

Solo exhibition at the Mercury Gallery, London.

1989

Included in the exhibition, *Scottish Art since 1900*, Scottish National Gallery of Modern Art, Edinburgh, and Barbican Art Gallery, London (1990).

Awarded an Honorary Doctorate, Heriot-Watt University, Edinburgh.

Commissioned to design a window for the National Library of Scotland.

Second retrospective exhibition, organised by the Welsh Arts Council and held at Aberystwyth Arts Centre, touring to venues in Brighton, Bangor, Cardiff, Bath and Lancaster.

1990

Awarded an Honorary Doctorate, University of Edinburgh.

Solo exhibition at Abbot Hall, Kendal.

1991

Commissioned by Scottish Provident to design a tapestry, woven at the Edinburgh Tapestry Company.

Commissioned by Glasgow Print Studio to produce a folio of ten etchings of orchids.

Solo exhibition celebrating sixtieth birthday, the Mercury Gallery, London.

1992

Elected Honorary Member of the Royal Watercolour Society, London.

Third visit to Japan.

1993

Commissioned by the Royal Mail to design a set of postage stamps showing orchids.

Solo exhibition at Glasgow Print Studio (*Orchids and other Flowers*) and the Mercury Gallery, London.

Included in *Writing on the Wall*, Tate Gallery, London, and *The Line of Tradition*, National Gallery of Scotland.

Fourth visit to Japan.

1994

Elected Honorary Fellow of the Royal Society of Edinburgh and Honorary Member of the Royal Society of Painter-Printmakers.

Commissioned by the University of Edinburgh to paint portrait of Sir David Smith, departing principal.

Solo exhibition at The Scottish Gallery, (Edinburgh Festival Exhibition).

1995

Commissioned by the Royal Mail to design a set of postage stamps showing cats.

Visited Indonesia, Penang and Malay, to paint orchids.

1996

Solo exhibition at the Mercury Gallery, London.

1997

Awarded an Honorary Doctorate, University of Aberdeen.

Commissioned to produce a screenprint for the National Museum of Women in the Arts, Washington DC.

1998

Awarded an Honorary Doctorate, University of Strathclyde.

Solo exhibitions at the Mercury Gallery, London (*35 Years of Printmaking*); The Scottish Gallery, Edinburgh, and Glasgow Print Studio (*Elizabeth Blackadder – Printmaker*).

Included in *Art from Scotland*, Forbes Magazine Galleries, New York.

1999

Second monograph on Blackadder's work, by Duncan Macmillan, published by Scolar Press.

Solo exhibition at the Scottish National Gallery of Modern Art, Edinburgh.

2000

Third retrospective exhibition: *Elizabeth Blackadder: Paintings, Prints and Watercolours 1955–2000*, Talbot Rice Gallery, University of Edinburgh.

Included in *Artists at Harleys: Pioneering Printmaking in the 1950s*, Hunterian Art Gallery, University of Glasgow.

Begins to exhibit with Browse & Darby, London.

2001

Appointed Her Majesty the Queen's Painter and Limner in Scotland.

Awarded an Honorary Doctorate, University of Glasgow.

Included in *Mirror Mirror – Self Portraits by Women Artists* National Portrait Gallery, London.

2002

Awarded an Honorary Doctorate, University of Stirling.

Included in *160th Anniversary Exhibition*, The Scottish Gallery, Edinburgh.

2003

Appointed DBE.

Solo exhibition at Glasgow Print Studio.

Elizabeth Blackadder Prints, by Christopher Allan, published by Lund Humphries.

Illustrations for *Through the Letterbox*, a book of haikus by George Bruce, exhibited at The Scottish Gallery, Edinburgh.

2004

Awarded an Honorary Fellowship, Edinburgh College of Art.

Solo exhibitions at The Scottish Gallery, (Edinburgh Festival Exhibition), and Browse & Darby, London.

2006

Commissioned by city of Edinburgh Council to paint a portrait of former Lord Provost Eric Milligan.

Solo exhibition at Browse & Darby, London.

First major joint exhibition with husband John Houston: *A Lifetime in Paint*, Edinburgh City Art Centre and touring to Aberdeen Marishchal Museum; Tolbooth Art Centre, Kirkcudbright; Paisley Museum, Paisley, and Bonhoga Gallery, Shetland.

2008

Death of husband, John Houston.

Solo exhibition at The Scottish Gallery, Edinburgh.

2010

Solo exhibition at Browse & Darby, London.

FURTHER READING

For a full bibliography, see Duncan Macmillan, *Elizabeth Blackadder*, Aldershot, 1999

Christopher Allan, *Artists at Harleys*, Glasgow, 2000

Christopher Allan, *Elizabeth Blackadder Prints*, Aldershot, 2003

Elizabeth Blackadder with Dr Brinsley Burbidge, catalogue introduction, *The Plant: Images of Plants etc*, Scottish Arts Council, Edinburgh, 1987

Judith Bumpus, *Elizabeth Blackadder*, Oxford, 1988

Edward Gage, *The Eye in the Wind*, London, 1977

Bill Hare, *Contemporary Painting in Scotland*, Sydney, 1992

Keith Hartley, *Scottish Art since 1900*, exhibition catalogue, National Galleries of Scotland, Edinburgh, 1989

Deborah Kellaway, *Favourite Flowers: watercolours by Elizabeth Blackadder*, London, 1994

William Kininmonth, *The Edinburgh School*, exhibition catalogue, Edinburgh College of Art, Edinburgh, 1971

Philip Long, *John Houston*, exhibition catalogue, National Galleries of Scotland, Edinburgh, 2005

Duncan Macmillan, *Scottish Art 1460-1990*, Edinburgh, 1990

Duncan Macmillan, *Scottish Art in the Twentieth Century*, Edinburgh, 1994

William Packer, in *Elizabeth Blackadder*, Scottish Arts Council exhibition catalogue, 1981

Elizabeth Blackadder was interviewed by Jenny Simmons in 2006, for *Artists' Lives, National Life Stories* © British Library. Catalogue reference C466/239.